WOMEN IN THE ARCHAEOLOGY AND HISTORY OF WEST NORFOLK

Further details of Poppyland Publishing titles can be found at
www.poppyland.co.uk
*where clicking on the 'Support and Resources' button
will lead to pages specially compiled to support this book
Join us for more Norfolk and Suffolk stories and background at*
www.facebook.com/poppylandpublishing
and follow **@poppylandpub**

Women in the Archaeology and History of West Norfolk:

Female voices across Time

Editor

Clive Jonathon Bond

POPPYLAND
PUBLISHING

Publisher's Note

This title covers contributions and invited chapters, celebrating the fiftieth anniversary of
the West Norfolk and King's Lynn Archaeological Society. The conference 'Women in the
Archaeology and History of West Norfolk: Female voices across Time' was held at Marriott's
Warehouse Trust, South Quay, King's Lynn on Saturday, 25th November 2017.

Cover photo: Archaeological Society members undertaking an optical sight survey at a moated
 manor house earthwork, Hilgay. (© 2015 Clive Bond)
Back cover photo: Test pit excavations at Hilgay Vintage Fair. (© 2015 Clive Bond)

Contents

List of Figures

Front Cover – Female Archaeological Society members in charge of the optical sight survey at a moated manor house earthwork, Hilgay, June 2015. From left, in ditch: holding measurements stave, Ian Iosson (Meetings' Secretary); Mike Neal (Society member, husband of Mim Neal). From right: on tripod Ciara Furlong (work placement); Mim Neal (Hon. Treasurer); lying down, adding to line drawing, Edward Cumbley (work placement); taking recordings of measurements Alvina De-Le-Mare (work placement; Cambridge University diploma student).

0.1. *Lynn News* article cutting, J. P. Smallwood (far left), founding member and chairperson at the first meeting, on 29th November 1967, at its inaugural lecture at Lynn Museum (WN&KL Archaeological Society *Scrapbook*, 1967).

0.2. J. P. and E. Smallwood, T. Gilding and colleagues, recorded the first features, some 39 pits containing later Neolithic pottery, at the later Neolithic/earlier Bronze Age enclosure/farmstead at Redgate Hill, Hunstanton in 1970 (in advance of the development of a road junction)(Front piece, After Bradley et al. 1993).

0.3. Top: A family group – a skilled team of female excavators, excavating a 1m x 1m test pit, on the 28th July 2013, Great Massingham. This archaeological outreach was part of the *'Gaywood Valley Archaeological and Historical Project'*. Bottom: trowels in hand, with Archaeological Society supervisors, friends and family, as the test pit reveals a mysterious 1 cm burnt layer! Bottom: Trowels at hand, all excavating, within the same 1m x 1m test pit. Note the 1cm black burnt layer – its origins remain to be explained (© Clive Bond 2013).

1.1. The author, left, second row back, second pirate in a dark waistcoat. Interpretation, through being a 'pirate', at True's Yard Fisherfolk Museum, 2010 (© Holly Isted 2010).

4.2. Aerial photograph of the moated manor house platform, taken using a drone. Arrow is pointing north, top right of photograph (© Kevin Elfleet 2015).

4.3. Plan of moated site with extensive fishponds, surveyed 1999 (After Cushion and Davison 2003, fig. 72).

4.4. Volunteers taking and recording readings from a 'dumpy level' across the western arm of the moat (© Clive Bond 2015).

4.5. Aerial photograph of the moat (taken by drone on 7.6.15) compared with Cushion and Davison's 1999 plan (Extract after Cushion and Davison 2003, fig. 72).

4.6. Top left: Extract from 1999 survey plan (Cushion and Davison 2003, no. 1 in fig. 72) set in line with hachures (below) based on measurements taken at Tripods 1 and 2. Centre right: Tripod and measured transect data in metres. Bottom: Profile sections of moat ditch. Each profile demonstrates differences in shape between the two Tripod points.

4.7. Drone survey vertical image combined with observations on the ground from the walkover survey assessing the earthwork condition (After De-La-Mare 2015, figure 9).

5.1. Author, with a range of prehistoric and historic plain and glazed wares on display (© Kate Phillips 2017).

5.2. A replica of a later prehistoric bowl. This was produced for *'Living History Teachers.'* The decoration and form appears very similar to an early Iron Age Le Tène globular bowl pottery form, technology dating to c.700-400 cal. BC: function food vessel and storage bowl (© Kate Phillips 2017).

5.3. A replica cremation bowl - a Cleathan Cremation Urn, Viking period. This urn was made for BBC children's programme, *'Wolf Blood'* (© Kate Phillips 2017).

9.1. Diana Bullock seated, surrounded by a group of King's Lynn Town Guides in 1993 (© Bob Price 1993).

9.2. Hampton Court, looking south-east across the courtyard, as the wing is being re-rendered, building conservation in action, 30th October 2017 (© Clive Bond 2017).

10.1. Notice, pasted on to wooden plaque, with E. M. Beloe's hand written inscription and above, centre circle void, drilled with shrapnel cross hung. Ten Centimetres scale, left side (© Alexandra Lee 2014).

10.2. A close-up, detail of the circular void, drilled in the wooden plaque, with shrapnel cross hung of a pin with an eye. Five Centimetres scale (© Alexandra Lee 2014).

11.1. St Margaret's Conservation Area and its relationship to the Townscape Heritage Initiative area (eligible for grants) (Produced, courtesy of the Borough Council of King's Lynn and West Norfolk).

11.2. Top: Greyfriars Chambers; Middle: 9/11 St James Street; Bottom: Wenns Hotel. Conservation works in progress, 24th October 2017 (© Elizabeth Nockolds 2017).

11.3. 'Beer, Butchers and Barbers' fair on the Saturday Market Place, September 2015 (© Elizabeth Nockolds 2015).

Contributors

A list of the authors in alphabetical order who have contributed to this book with some biographical details:

Lindsey Bavin, BA (Hons), MA, FRSA
Museum Manager at True's Yard Fisherfolk Museum
Trustee of The Marriott's Warehouse Trust
Member of the History and Archaeology Sub-Committee, King's Lynn
Hanse Club.
www: https://truesyard.co.uk/
www: http://www.marriottswarehousetrust.co.uk/
www: http://www.hansehouse.co.uk/history-and-archaeology-sub-committee/

Lindsey grew up in King's Lynn and went to King Edward VII High School. She left to attend the University of Wales, Lampeter for her Bachelors and Masters degrees and briefly lived in Edinburgh before returning to King's Lynn in 2012. She became involved with True's Yard Fisherfolk Museum through volunteering and worked her way up to become the manager of the Museum. In 2015 she co-wrote *King's Lynn and the Hanseatic League* with Deputy Manager, Rebecca Rees, which was given free to all Year 5's in the area. Lindsey is also a trustee of The Marriott's Warehouse Trust and a Fellow of the RSA. She is currently working towards her Associateship of the Museums Association.

Clive Jonathon Bond, BA (Hons), MA, PhD
Chairperson, West Norfolk and King's Lynn Archaeological Society
Visiting Research Fellow in Archaeology, Department of Archaeology and Anthropology, The University of Winchester, Winchester
www: http://wnklas.greyhawk.org.uk/main.php
www: https://winchester.academia.edu/CliveBond
http://www.winchester.ac.uk/academicdepartments/archaeology/staff/Pages/Staff.aspx

Clive is a prehistorian and landscape archaeologist. He studied at the University of Leicester for his undergraduate and masters degrees, including studying and excavating in northern and central Italy. He then studied and worked at the University of Birmingham, before going into

commercial archaeology. He has taught undergraduates and MA students at the Universities of Birmingham, East Anglia, Winchester and Cambridge and gained his PhD in 2006 (Winchester; awarded by the University Southampton). His thesis was on the *'Prehistoric Settlement of Somerset: Landscape, Material Culture and Communities, 8,300 to 700 cal. BC.'* Clive has worked, and continues to work, as an archaeological consultant, most recently for the Department of Archaeology, at the University of Reading and the Borough Council of King's Lynn and West Norfolk. He has also been a consultant for the Portable Antiquities Scheme and advised English Heritage on lithic scatters. He is a Visiting Fellow at The University of Winchester and has organised many academic and international conferences and conference sessions on prehistoric archaeology. He's published over twenty peer-reviewed academic papers on different aspects of British prehistory, later Upper Palaeolithic to later Bronze Age; lithic scatters, lithics and prehistoric pottery analyses; prehistoric beliefs; survey techniques, landscape and community archaeology. Clive was asked to take on the role of chairperson in 2010-11, returning to his local Archaeological Society, that he was initially a member of when he was an 'A' Level student at King Edward VII High School in the late 1980s. The Society and John Smallwood gave him his first opportunity to excavate, at Vong Lane, Pott Row (NHER 24054), Grimston in 1988-89. (This was the medieval pottery kiln and domestic site, directed by Mark Leah for the Norfolk Archaeological Unit). Clive also works as an Infrastructure Planner for the London Borough of Camden.

Gillian Bond, BA (Hons), MSc, CPsychol.
Programme Action Officer, Soroptimist International, King's Lynn
www: https://sigbi.org/kings-lynn/

Gillian is a Chartered Psychologist whose career history includes building a psychology department from scratch for an employee communications consultancy which became one of the top three companies in the UK for the services it provided. On the board of directors, she was a Director of Organisational Development, responsible for the branding and development of the psychology services the company provided. She went on to run her own business and offered; training, coaching, career management and organisational development consultancy to businesses

across all sectors. She ran a private counselling practice and managed a 24hour counselling service for a UK wide employee assistance scheme, filling in for the Managing Director. She has developed ground breaking coaching models which have gained national acclaim and enabled many people from all walks of life to achieve their personal and career goals. Gillian has been a guest lecturer on the University of Birmingham's MBA programme, lecturing on positive psychology and career management to international MBA and PhD students. She has been featured in national and regional press articles for business coaching, positive psychology, career management, stress management and employee communication issues. She provides quotes and direction to media on psychology related issues. Gillian is currently Programme Action Officer for Soroptimist International, King's Lynn. She has been Chairman for West Midlands Women in Business Association and was one of the founder members and Programme Action Officer, Soroptimist International, Solihull Club.

Alvina De-La-Mare, BA (Hons), Diploma in Archaeology
Research Assistant, West Norfolk and King's Lynn Archaeological Society
Library Assistant, Ely, Cambridgeshire County Council

Alvina was born in Cornwall but growing up in the Fens she gained an enduring bond with landscape which heavily influenced her later studies in Art and Creative Practice with her BA (Hon) degree in Visual Studies at Norwich University College of the Arts where she received a 1st Class Honours in 2010. This evolved into a fascination for Prehistoric Art and Archaeology which she developed further by completing a year's Undergraduate Diploma (III) in Archaeology at the Institute of Continuing Education, the University of Cambridge. As part of the diploma Alvina joined the Archaeological Society's 'Ouse Washes Landscape Partnership Community Archaeology (Norfolk)' project (2015), as a work placement. Over the summer of 2015, she gained some excellent hands-on experience and comprehensive involvement of an excavation from start to finish, as well as developing more analytic and illustrative techniques. Alvina's long-term Library Assistant role enables her to explore all manner of interesting paths as a laywoman, and her experience as a novice archaeologist has been invaluably enriching.

Holly Isted, BSc (Hons), PGCE
Heritage Learning and Interpretation Specialist,
Churches Conservation Trust, St Nicholas' Chapel, King's Lynn
www: https://www.visitchurches.org.uk/visit/church-listing/st-nicholas-chapel-kings-lynn.html
www: http://www.stnicholaskingslynn.org.uk/

Holly Isted has a degree in Heritage Conservation and a PGCE in secondary education. She has lived and worked in West Norfolk for ten years in both mainstream education and heritage settings. She is currently the Learning and Participation Officer at St Nicholas' Chapel where she is delivering an extensive Heritage Lottery Funded activity plan featuring a variety of learning and engagement projects. Holly has also established a successful Heritage Learning Forum in King's Lynn.

Alexandra Lee BA (Hons)
Member of the West Norfolk and King's Lynn Archaeological Society

Alexandra Lee graduated from university in 1994 with a BA (Hons) in English Literature at Middlesex University, after completing a foundation diploma in Art and Design. After graduating she worked for several years as a Production Manager for an independent television production company in London, making British news and human-interest stories for overseas broadcasters. More recently she has worked in publishing, and a pupil referral unit for children excluded from mainstream schools. She joined a pharmaceutical company in Norfolk in 2016 and has recently been appointed as their first 'Diversity Champion'. She has volunteered as a guide for the National Trust, and ran a community allotment for several years, receiving a 'Local Food Heroes' Award from the High Sheriff of Norfolk, Lady Leicester. She is a keen gardener, and runs an occasional travelling stall selling vintage and retro fashion accessories. Alexandra has volunteered for The Temple Trust in Gunnersbury Park in London, and for Garden Organic as a Master Gardener. Alexandra also worked as volunteer on a number of West Norfolk and King's Lynn Archaeological Society projects: Kettlewell Lane Gardens World War II Air Raid Shelter (2012); the Gaywood Valley Archaeological and History project (2013); Zeppelins over Lynn and the Royal Flying Corps Home Defence (2014).

Alice Lyons BA (Hons), MA, MCIfA
Project Officer, Oxford Archaeology East, Cambridge
PhD Researcher, School of Art History and World Art Studies, the University of East Anglia, Norwich. Thesis: *Adopting a Roman way of Death in the Provinces: Characterizing cultural life, community aspiration and funerary choices by means of contextualised analysis of the associated pottery assemblages.*
www: https://oxfordarchaeology.com/ourpeople?letter=L
www: https://www.uea.ac.uk/art-history/people/research-students

Alice started her archaeological career as a volunteer excavator at The Brooks excavation in Winchester and went on to study archaeology at York University (1986-89). After graduation Alice worked for 17 years for the Norfolk Archaeological Unit (NAU) where she developed an interest in Roman pottery. After leaving NAU she was freelance for a short period before starting working for Oxford Archaeology East (2007 to the present), during which time she also undertook a Masters in Ceramics and Lithics at Southampton University (2008-9). Alice continues to work for Oxford Archaeology East as a post-excavation specialist while studying for a PhD at the University of East Anglia.

Susan Maddock BA (Hons)
Honorary Research Fellow, School of History, the University of East Anglia, Norwich
www: https://www.uea.ac.uk/history/people/profile/list/honorary/io

Susan Maddock is an Honorary Research Fellow in the School of History at the University of East Anglia. An independent scholar, she began mapping the social topography of Lynn in the fourteenth and early fifteenth centuries following her retirement in 2013 from the post of Principal Archivist at the Norfolk Record Office. As part of her working role at the Norfolk Record Office, she was responsible for King's Lynn Borough Archives for more than 30 years.

June Mitchell MBE
Chairman
Tilley All Saints History Group
www: www.tilneyallsaintsonline.org.uk

June was born in Lanarkshire, Scotland in 1939, and is a trained nurse, midwife and health visitor. She was awarded her MBE 'for services to SW Hertfordshire Health Authority' in 1991. Following studies at Bible College, June spent four years in North India as a medical missionary. She is married to Ian, and they took a semi-retirement move from Watford to Tilney All Saints, Norfolk in 2000, and have never looked back. They love the county, their village and the less hectic rural lifestyle. They are both active in the King's Lynn Church of the Nazarene. June finally retired from the NHS in 2004, and then began the new interest of research, firstly in Family History, and then Local History.

Cllr. Elizabeth Nockolds
Deputy Leader of the Borough Council of King's Lynn & West Norfolk
Cabinet Member for Culture, Heritage and Health
Chairman of King's Lynn & West Norfolk Area Museums Committee
Member of the Norfolk Joint Museums and Archaeology Committee
www: http://democracy.west-norfolk.gov.uk/mgUserInfo.aspx?UID=189

Elizabeth is a happy wife, mother and grandmother. She was born in a village in west Norfolk. As a result of the 1953 floods her family was forced out of her parent's home and moved to Watlington where she spent her young life. She has worked for the NHS for 25 years and during the last few years for Marie Curie nursing. During Elizabeth's two daughters school life she was a school governor both at the Primary and High School. She is still a governor at South Wootton Infants School. Her main interests are working and volunteering in the community which she enjoys. She is a Trustee of two sets of alms houses and in the past has been a Victim Support Councillor. It was because of her voluntary work she decided to stand as a candidate in the Borough Council elections. Elizabeth feels privileged to have been a Borough Councillor since 1993.

Her leisure activities are walking, cycling, attending theatre and visiting places and she is a member of the National Trust.

Kate Phillips BA (Hons)

Associate Member, Craft Potters Association
Member, Greyfriars Art Space, King's Lynn, Norfolk
Bodgers Farm Studios Pottery, Black Drove, St. John's Fen End
Wisbech, Cambridgeshire PE14 8JU
www: http://bodgersfarmpottery.co.uk/index.html

Kate completed a degree in Ceramics and Glass at Chilterns University in 2001. In 2002 she established her ceramic business, *Bodgers Farm Studio Pottery*, at St John's Fen End, near Wisbech. Over the past twelve years Kate has researched her love of ancient pottery, in particular that from the Viking and Medieval periods. Commissions have varied from Bronze Age beakers to Tudor candle sticks. Various clays reflect different geographical areas and each pot has its own provenance. All Kate's pottery supplied for re-enactment is designed to be used. It is fired to a much higher temperature that her potter ancestors were able to achieve resulting in far more hard-wearing pots. In addition, Kate uses modern food-safe glaze recipes and for hygienic purposes glazes the interior surfaces unless otherwise requested. Replica pottery for museum display is made as accurately as possible from historical reference research.

Jill Price

Jill is well known in King's Lynn and west Norfolk: as a teacher and magistrate she is known to many. She's also been an active Town Guide and member of many local societies, including the King's Lynn Civic Society, West Norfolk Association of the National Trust Members, The Arts Society (NADFAS) and University of the Third Age (U3A). So, she needs little introduction to any of us. She was asked to be the honorary chair for the Archaeological Society's fiftieth anniversary conference, for her outstanding ability and commitment to the community.

Elizabeth Pye, MA (Hons), FSA, FIIC

Emeritus Professor of Archaeological and Museum Conservation
University College London, Institute of Archaeology, London
Programme Action Member, Soroptimist International, King's Lynn
www: https://www.ucl.ac.uk/archaeology/people/staff/pye

Elizabeth Pye is an archaeologist and conservator. Now retired, for most of her career she lectured in conservation at University College London.

Her professional practice included conservation at a number of archaeological sites around the Mediterranean, and involvement in an international project focused on museum training in Sub Saharan Africa. She is the author of *Caring for the Past: Issues in Conservation for Archaeology and Museums* (2001), as well as a number of papers on conservation, and editor of *The Power of Touch: Handling Objects in Museum and Heritage Contexts* (2007). Currently she is editor of the journal *Archaeology International*. Her interests are in preindustrial technologies, historic buildings and the visual arts.

Introduction

Clive Jonathon Bond

Origins

The idea for this book came from a request that I organise a conference to celebrate the fiftieth anniversary of the West Norfolk and King's Lynn Archaeological Society. The Society's first inaugural lecture was held at Lynn Museum on the 19th November 1967.

I wanted a different topic and was keenly aware, as far as I knew, that a meeting of women working in or on the subject of 'Women in the Archaeology and History of West Norfolk' had not previously been held. This appeared an oversight, as I suspect many of my generation of archaeology graduates studied gender studies as part of their degree, now over twenty years ago, and were inspired by the subject and approach (e.g. Allason-Jones 1989; Gero and Conkey 1991; Gilchrist 1994). Away from academia I often found that gender was not addressed, or debated in the same way. Indeed, I had been greatly helped and inspired by a key Norfolk female archaeologist and prehistorian whilst working on my MA dissertation in 1993 (Bond 1994), Dr. Frances Healy (1991, 1996). Therefore, the conference and book, was born: to provide a different platform for the female voice and perspective on West Norfolk's rich heritage.

West Norfolk and King's Lynn Archaeological Society

The Society has a long and distinguished history. Mr. John Smallwood, a history teacher at the former King Edward VII High School, King's Lynn with others supporting the Committee, notably John (J.O.H.) Nicholls (then, Norfolk College of Arts and Technology), founded the group with its inaugural lecture at Lynn Museum on 29th November 1967 (Fig. 0.1).

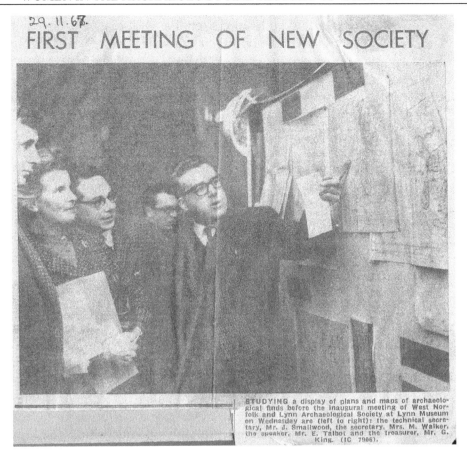

Figure 0.1. *Lynn News* article cutting, J. P. Smallwood (far left), founding member and chairperson at the first meeting, on 29th November 1967, with its inaugural lecture at Lynn Museum (WN&KL Archaeological Society *Scrapbook*, 1967).

From Antiquarianism, Rescue Archaeology to Archaeology for All: Both John Smallwood, or as he was affectionately known 'J.P.S.', to his students, and J. O. H. Nicholls and others, have been the main fieldworkers who contributed to discovering the archaeology in west Norfolk in the post-War period. Indeed, John Smallwood often refers to John Nicholls as 'the founder member', as he was active in local fieldwork before the 1939-45 war. For example, John Nicholls excavated with Mr. Thatcher, the King's Lynn Docks Manager, in the early 1930s at Reffley Barrow, at Knights Hill, South Wootton.

It is also worthy of note that both John Nicholls, with his wife, Gwen, and John Smallwood, Elisabeth, and their families were all involved in discovering and recording west Norfolk's archaeology. Women were active, in and among the Archaeological Society team's that recorded threat-led evaluations. Indeed Frances Healy recalls the team's composition about the excavation of the later Neolithic enclosure and pits at Redgate Hill, Hunstanton, in the of winter 1970,

> 'The removal of topsoil progressively revealed archaeological features cut into the underlying chalk. These were investigated by three local archaeologists, Mr. Tony Gilding and Mrs E. [Elisabeth] and Mr. J. P. Smallwood. Who between late February and early March recorded thirty-nine pits and a larger, irregular feature named the 'complex', as well as collecting unstratified material.'

(Healy 1993, 1).

Between John Nicholls and John Smallwood, they conducted targeted rescue excavations, surveys ahead of road building and recorded thousands of artefacts from ploughed fields. They contributed to hundreds of new Norfolk Historic Environment Records over decades of fieldwork. Above all, John Smallwood and his colleagues and friends inspired generations of local students and volunteers. This, a priceless contribution to knowledge: young and old knowing more about, valuing and recording their own Archaeology in their patch of Norfolk!

The Archaeological Society developed out of a group of committed amateur archaeologists in the post-war period supported by the local and regional museum staff. It built good relations with local antiquarians, writers, field walkers and landowners, such as Hamon Le Strange and Charles Lewton Brain (Charles Lewton Brain 2009; Le Strange 1968).

Members field walked and occasionally excavated sites; this was a fruitful position to be in, as when large-scale road building occurred and urban development was scheduled, in the late 1960s-80s, members led attempts to record archaeology prior to the arrival of bulldozers on site! Out of sound basis of antiquarian knowledge and a strong tradition of fieldwalking and

collecting, in the 1960-70s emerged a local Society spearheading fieldwork as 'Rescue Archaeology' (Fig. 0.2), in rural West Norfolk!

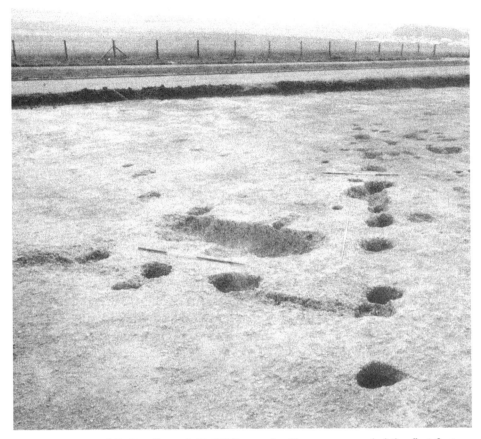

Figure 0.2. J. P. and E. Smallwood, T. Gilding and colleagues, recorded the first features, some 39 pits containing later Neolithic pottery, at the later Neolithic/earlier Bronze Age enclosure/farmstead at Redgate Hill, Hunstanton in 1970 (in advance of the development of a road junction) (After Bradley *et al.* 1993, front piece).

This was at a time when no County-based or commercial archaeological system existed to record and document archaeology prior to development. The quantity and quality of metal detector finds, discovered by members of the Society, other groups and individuals, led by the late Tony Gregory, Field Officer for the Norfolk Archaeological Unit, in the 1970s-80s, laid the foundations for the systematic recording of metal detector finds in Norfolk and across England. This approach, with close-working with keen

and knowledgeable amateurs on the basis of trust and respect, led to the establishment of the Portable Antiquities Scheme in 1996-7, supporting the new Treasure Act.

Today's Community Archaeology: Educational outreach has always been part of the Society's aims; 'A' level and GCSE students from King Edward VII High School, elective students from the College of West Anglia (formerly Norfolk College of Arts and Technology) and other students were encouraged to learn and be actively involved in recording the archaeology and heritage of the area.

An educational emphasis has continued to this day, with recent work placements, on community archaeology outreach projects since 2011 and working with Access Cambridge Archaeology delivering Higher Education Field Academies since 2010. Selected recent projects worthy of mention are (Fig. 0.3): survey work of a World War II Air Raid Shelter at Kettlewell Lane, King's Lynn in 2012 (NHER 31205); the successful Heritage Lottery Fund supported 'Gaywood Valley Archaeological and Historical Project', 2013 and other projects; Norfolk Community Foundation supported, 'Zeppelins over Lynn', 2014-15; the first intertidal archaeological foreshore survey of the River Great Ouse, 2014; the Heritage Lottery Funded 'Ouse Washes Landscape Partnership Community Archaeology (Norfolk)' project, 2015.

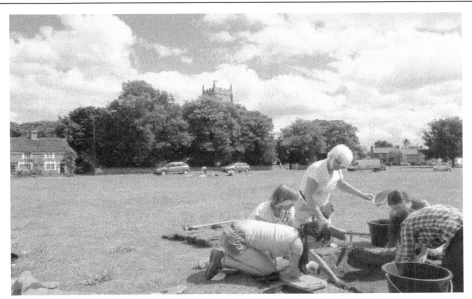

Fig. 0.3. Top: A family group – a skilled team of female excavators, excavating a 1m x 1m test pit, on the 28th July 2013, Great Massingham. This archaeological outreach was part of the *'Gaywood Valley Archaeological and Historical Project'*. Bottom: trowels in hand, with Archaeological Society supervisors, friends and family, as the test pit reveals a mysterious 1 cm burnt layer! Bottom: Trowels at hand, all excavating, within the same 1m x 1m test pit. Note the 1cm black burnt layer – its origins remain to be explained (© Clive Bond 2013).

Book Structure

This book offers a record of some of the approaches towards, and by, women in researching and studying the archaeology and history of west Norfolk. Eleven chapters move from personal experiences on career or projects (Isted; Mitchell); artefact studies (Lyons; Lee); fieldwork (De-La-Mare) studies; historical sources and persons (Maddock; Bavin); to notable women (Bond and Pye; Price) and present-day heritage-led regeneration in King's Lynn (Nockolds). These chapters, I believe, demonstrate the vitality of approaches by women in our community today. This mix of contributions has come as a pleasant surprise and is inspirational. I hope you'll find them all of interest and inspiring too!

Acknowledgements

Firstly, I'd like to thank the publisher Peter Stibbons of Poppyland Publishing, for his interest and support for this project. Secondly, I would like to thank the speakers for the conference, and each contributor to this book: thank you for your contributions, some of you working at short notice, with busy lives and commitments to balance. Thirdly, I'd like to thank those people who have made a contribution to the conference: Marriott's Warehouse Trust; the many tea and cake makers; those providing posters and stalls (both members of the Archaeological Society and non-members). Fourthly, and lastly, I need to thank my family: mum, my late father and sister; Betty, John (Bill) and Gillian Bond. They have always been by my side and supported my archaeological endeavours, including on site, at conference, and at home as proof reader and tea maker (mum) over so many years. I dedicate this book to my family, who without their support, I would not have been able to take up and take forward the Chairperson's role of this illustrious local Archaeological Society!

All Saints' Day, 1st November 2017.

References

Allason-Jones, L. 1989. *Women in Roman Britain.* London: British Museum Publications.

Bond, C. J. 1994. *'The relationship between settlement on the Fen-edge and Claylands in Norfolk: the prehistoric and historic colonisation of the Wissey Valley.'* Unpublished MA Dissertation. Leicester: School of Archaeological Studies, University of Leicester.

Gero, J. M. and Conkey, M.W. (eds.), 1991. *Engendering Archaeology: Women and Prehistory.* Oxford: Blackwell.

Gilchrist, R. 1994. *Gender and Material Culture. The Archaeology of Religious Women.* London: Routledge.

Healy, F. M. 1991. 'Appendix 1. Lithics and Pre-Iron Age Pottery', 116-139. In Silvester, R. J., 1991. *The Fenland Project, Number 4: Norfolk Survey, The Wissey Embayment & Fen Causeway.* Dereham: East Anglian Archaeology Report No. 52.

Healy, F. M. 1993. 'Introduction', 1-4. In Bradley, R., Chrowne, P., Cleal, R. M. J., Healy, F. and Kinnes, I., *Excavations on Redgate Hill, Hunstanton, Norfolk, and at Tattershall Thorpe, Lincolnshire.* Dereham: East Anglian Archaeology No. 57.

Healy, F. M. 1996. *The Fenland Project, Number 11: The Wissey Embayment: Evidence for pre-Iron Age Occupation.* Dereham: East Anglia Archaeology Report No. 78.

Le Strange, H. 1968. 'A collection of flint implements from the Hunstanton district'. *Proceedings of the Cambridge Antiquarian Society*, 61, 1-7.

Lewton Brain, C. 2009. *Walking on Buried History.* Dereham: Larks Press.

Chapter One

A Sense of Place

Holly Isted

Abstract

Heritage interpretation is still a relatively new field; to many it began in 1957 with the publication of Freeman Tilden's Interpreting Our Heritage. *In this chapter I describe how I began my journey in a career in heritage interpretation and how I found my sense of place in West Norfolk and came to help others do the same. Discussed are the challenges faced within interpretation; the need for expertise; and the future, particularly relating to mental health practice and a new era of patriotism.*

Introduction

Heritage interpretation is still a relatively new field; to many it began in 1957 with the publication of Freeman Tilden's *Interpreting Our Heritage* (2007). Since then the desire of people to *experience* history rather than just be informed has grown. As technology and fashion changes so do the ways in which we interpret, yet the objective remains the same - to find a sense of place; to reveal meanings and relationships that connect people across time and space.

In 2010 I began a career in the heritage industry when I took up the post of Education and Community Outreach Worker at True's Yard Museum (Fig. 1.1). In a way I found my own sense of place, having, until then, been on a long and frustrating journey trying to find direction in my life
.

Personal Journey and a *'Sense of Place'*

At school I wanted to be an artist. However, my problem was that I wanted to be a more conventional artist, and that was not what they encouraged at art college. I was once asked to sculpt the essence of a washing up brush and a fir cone; I didn't finish the course. It was purely by chance gazing through the weighty UCAS catalogue of courses, that I found Heritage Conservation.

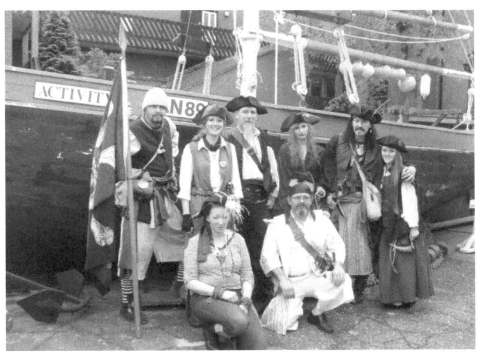

Figure 1.1. The author, left, second row back, second pirate in dark waistcoat. Interpretation, through being a 'pirate', at True's Yard Fisherfolk Museum, 2010 (© Holly Isted 2010).

I was born in Kent and grew up in Surrey; when I look back now I realise that I was surrounded by historic buildings, in fact, at the age of about 16, when my English teacher asked the class what we would miss most about England, I remember clearly saying 'the buildings.' One house in particular always stands out - Knole House in Sevenoaks, Kent (Fig. 1.2).

Set in an extensive deer park, it was just a short walk from my grand-parents tiny farmer's cottage. It was my playground whenever I stayed with them, and was the inspiration for several art projects and also the focus of an A-level Geography project. It also had an infamous 'swingy' tree which delighted children and adults alike. Sadly, due to health and safety regulations, the long, low swingy branch is no more. With Knole House in mind I applied for the course, not really sure of what career it would lead to. An existing student soon clarified it for me – 'Archaeologists dig it up; we work out what to do with it.'

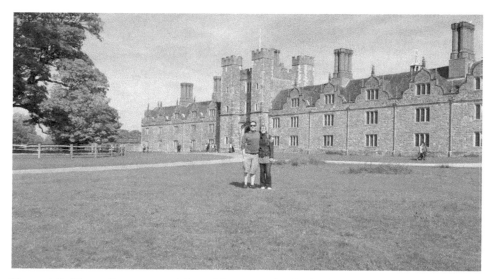

Figure 1.2. The author centre, right, with partner. In the background, the very impressive historic property managed by the National Trust, Knole House in Sevenoaks, Kent (© Holly Isted 2017).

After University I went travelling and met a number of teachers who inspired me to complete a PGCE on my return to the UK. Ultimately, however, being stuck in a classroom with an interactive whiteboard and instructions like, 'don't mark in red, it's an angry colour and will upset children', wasn't for me. A few years later, True's Yard Fisherfolk Museum gave me the chance to combine both teaching and heritage and I haven't looked back.

All my jobs in heritage have tended to have different, rather convoluted titles but they have essentially focused on education and interpretation. The two are almost always automatically put together, as if they are the same thing, but there is a subtle yet fundamental difference between them. In education the focus is on learning, often with very specific outcomes and objectives particularly with school curriculums; the bonus with education is that the audience enjoys themselves. Interpretation is the other way around, the focus is on enjoyment and the bonus is that the audience go away having learnt something. Remember with education you tend to have a captive audience; with interpretation your audiences are giving up their free time, so you have to work harder to maintain their

interest. People working in interpretation often mistakenly focus on one of two extremes, on either the learning (or the exchange of information) at the expense of fun, or on the fun at the expense of any learning. I was once shown a scrappy cutting from an unknown magazine, the statement on which I remember to this day:

> 'When I was young and visited museums I was a child in an adult's world; now I am an adult in a child's world.'

Why Interpretation?

I have often been asked why we go to the trouble of interpreting information, why instead can't we put all the information out for people to either 'take it or leave it', if they are not interested they are not interested. Heritage interpretation often gets a bad reputation as 'the dumbing down of information', or the 'Disneyfication' of the past. Some people also think it is just pandering to an attention deficit generation of social media users.

Freeman Tilden is considered by many to be the father of heritage interpretation. His book, first published in 1957, is required reading among interpreters. There is one particular sentiment that has stayed with me throughout my career - that information on its own is sterile. Through interpretation comes understanding; through understanding comes appreciation and through appreciation comes protection (Tilden 2007, 8). He was writing principally for the American national parks, but his words are relevant to all types of heritage sites. Our aim in heritage is not a sterile information exchange, it is to share our own passion and knowledge in a way that engages and inspires as many people as possible, so that their lives are enriched and that they become supporters of our heritage – be that through visiting, volunteering, donating or behaviours and attitudes that help to support, conserve and sustain the future.

> 'In drying plants, botanists often dry themselves. Dry words and dry facts will not fire hearts.'

John Muir (n.d.).

Tilden (2007, 34-35) set out the following six key principles:

'1. Any interpretation that does not somehow relate what is being displayed or described to something within the personality or experience of the visitor will be sterile

2. Information, as such, is not interpretation. Interpretation is revelation based upon information. But they are entirely different things. However, all interpretation includes information

3. Interpretation is an art, which combines many arts, whether the materials presented are scientific, historical, or architectural. Any art is in some degree teachable

4. The chief aim of interpretation is not instruction, but provocation

5. Interpretation should aim to present a whole rather than a part and must address itself to the whole man rather than any phase

6. Interpretation addressed to children (say, up to the age of twelve) should not be a dilution of the presentations to adults but should follow a fundamentally different approach. To be at its best it will require a separate programme.'

Interpretation can also relate to instructional information, for instance, an 'Out of Order' sign on a toilet door is frustrating to say the least. It will almost always elicit a negative feeling, about the toilet, of course, but also about the place in general being seen as a sign of poor management. If, however, the sign includes an explanation and apology, the reaction tends to be very different. For instance, whilst working at Bodiam Castle I drafted a notice, as follows,

'Due to problems with our Victorian plumbing this toilet is currently out of order. We apologise for any inconvenience caused.'

People are generally more understanding and sympathetic, and are less likely to refer to it in their *TripAdvisor* review.

Who interprets and who do we interpret for?
For interpretation to be effective we must first make sure that the right people are involved in creating and delivering it. Do they have the right expertise? Do they understand what interpretation is and why it is important? Thus, it has been pointed out,

> 'Heritage interpreters come from all walks of life. They are teachers, storytellers, writers, artists, curators, designers and scientists. They are often creative and usually passionate about nature, history or art. Above all, they are gifted communicators in one way or another.'

Association for Heritage Interpretation (2017).

Once the right people are in place, we need to establish who the audience is. This is commonly where interpretation falls foul. Passionate people are often at risk of interpreting for themselves; it is very easy to get caught up in a subject you love and forget about the purpose of the project. In my experience there also tends to be an assumption that anyone passionate about or knowledgeable in a subject is automatically a good communicator; that is not always the case. As a result, too much information can be conveyed in a way that is only accessible to a few, like-minded people. It is, therefore, essential to understand the target audience, or more accurately audiences.

As Oliver Mantell (2017) explains,

> '...There are always multiple audiences, even if they turn up in the same place and at the same time to see the same thing. There will always be differences between them: who they are, where they're from, what they do, what they think, feel and believe. And, crucially, within those many differences are the few distinctions that matter most – the ones that, by understanding them, will make most impact. The challenge is to find them...'

(Mantell 2017).

It's impossible to treat all audiences the same, just as it is impossible to tailor every aspect of what you do and how you do it to each individual. School teachers are confronted with a similar challenge in classrooms. Even with personalised learning, no teacher can tailor a lesson to meet all the differing needs of thirty plus pupils. The practice of, 'teaching to the middle' is used, with differentiated tasks and additional programmes to support gifted and talented pupils, and those with special educational needs. The approach in interpretation is very similar. We have to find a middle ground, and then use 'layers of interpretation' to appeal to different audiences. This can feel like an uncomfortable compromise, but if the right people are in place it should never be a 'dumbing down' of information. Interpreters also need to remember their existing audiences when trying to engage new ones.

To help understand audiences, many organisations use audience segmentation, which involves creating detailed profiles for categories of visitors. These are in essence generalisations, stereotypes which when used for the right reasons and developed with suitable sensitivity and respect for audiences, can enable organisations to be more inclusive and democratic as well as resilient (Mantell 2017).

In my experience visitor profiles have been very useful, not just in creating interpretation but also in advertising and marketing the visitor experience. The problem comes when local audiences don't match national profiles, and there is no appetite or support for further research or outreach. There is sometimes a, 'one size fits all' approach which not only fails to understand audiences but also ignores the contribution made by locally based staff and volunteers. Even with good audience segmentation, however, mistakes can be made.

Case Study: Bodiam Castle, East Sussex
I started working at Bodiam Castle in the Olympic summer of 2012, as the Learning and Interpretation Officer. Bodiam Castle (Fig. 1.3), owned by the National Trust, is an iconic castle situated in 1066 'country', East Sussex.

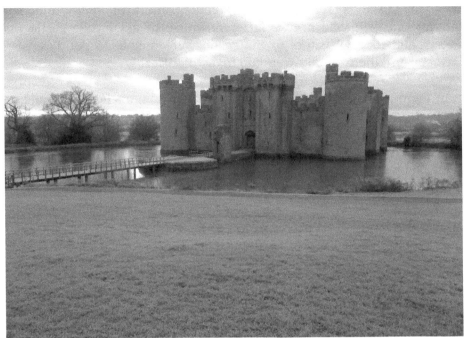

Figure 1.3. The impressive moated, exterior of the National Trust owned Bodiam Castle, East Sussex (© Holly Isted 2017).

It has never struggled with visitor numbers, particularly from family audiences, and was the busiest site for schools within the Trust's south-east region during my time there. Interpretation was varied and considered to appeal to all the key audiences, for which there were detailed visitor profiles. An extensive visitor survey, however, showed that expectations were not being met, with the emotional impact of visits scoring low.

Following workshops to address and understand the results of the survey which involved staff and volunteers, it became apparent that the team had unintentionally been interpreting the castle for themselves - not just failing to meet visitor expectations, but at times confusing them. Most visitors simply expected to explore an iconic, moated, medieval castle. What they were presented with was the history of the site from Roman times through to World War Two, advertised as a visit to a typical "fairytale castle", the term used by Lord Curzon who donated the castle to the Trust in the 1920s. I suspected, however, that visitors in the 1920s

(prior to Disney's reimagined conceptualization of *their* trademark "fairytale castle"), had a very different image of a fairytale castle than modern audiences. Visitors to the castle were unable to get a sense of place because there simply were too many on offer!

From the outside Bodiam Castle looks virtually untouched, its walls and towers intact with few additions. Surrounded by a moat designed to make the castle look bigger and more impressive, the outside scored high on emotional impact. This remained high as people walked across the bridge, under the original portcullis and into the gatehouse, but took a distinct nosedive when they were met with the ruined interior (Fig. 1.4).

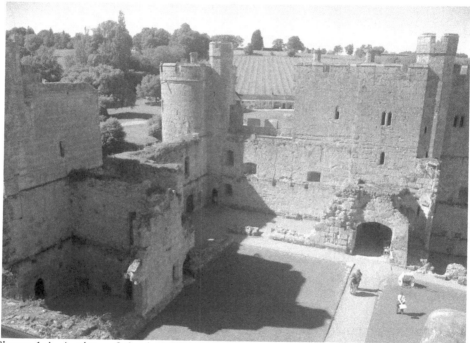

Figure 1.4. A view of the interior of the National Trust owned Bodiam Castle, with visitors exploring the structure (© Holly Isted 2017).

The difference was significant and disappointing, and little had been done to try to fill the space, apart from two underused costumed interpreters. The team now had to focus on interpreting the theme of a Medieval Castle, particularly on the inside. The first step was to develop the existing programme of costumed interpretation and thus fill the courtyard

with medieval characters; it proved a huge success. New layers of interpretation were then needed, particularly those which would appeal to family audiences. After putting the project out to tender, a company was selected who offered something bespoke, cutting edge and, at that point, unknown. Following the Agile development approach to project management, the end product would emerge and be shaped through a series of iterations and thus was not agreed on at the start.

The final product was an interactive game in which people had to decipher clues, and make choices to uncover a mystery (Fig. 1.5).

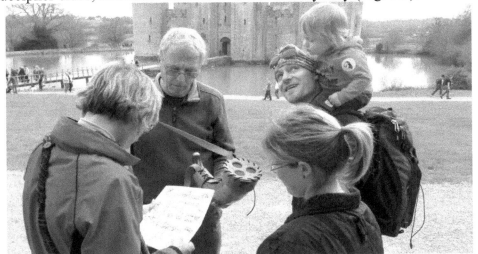

Figure 1.5. A group of visitors, with the author, right, taking part in the 'Castle Game', at the National Trust's Bodiam Castle, East Sussex (© Holly Isted 2017).

It was ultimately a success with family groups, but there were some key problems with the game, most notably:

- The history of the castle didn't quite meet the needs of the game, so it was changed (the history, not the game)
- The design team assumed that the Costumed Interpreters would be an extension of the game, and solve any technical issues on site. This conflicted with their role to present the factual history of the castle, and interact with visitors in character
- The game required props in the castle including text panels, which were not in keeping with existing items and not produced by

people experienced in interpretive writing. A popular model of the castle was removed, which prompted numerous complaints from regular visitors including school groups.

In my opinion the game didn't consider existing audiences or existing forms of interpretation. It was too narrow in its focus and involved the wrong people, as a result it, wasn't a true reflection of the sense of place. In this case, the problems began with the 'open scope' of the 'Agile' development system. Whilst creative and exciting, the undefined nature of the end product in the development stages understandably worried the National Trust as an organisation, thus the decision was made to change the staff managing the project very early on. The original team, which had had the benefit of and learned from the aforementioned workshops where the results of the visitor surveys were discussed, were downgraded to merely 'optional' consultants, to be used as and when required - in practice this was rare. Unfortunately, the new team lacked the time, knowledge or expertise and the project hit problems at an early stage, with wider staff and volunteers quickly feeling alienated.

The game has now been removed as the focus on site has once again altered following a change in management. Families are no longer the *desired* audience; the popular children's sandpit in the castle grounds has been removed, as have the replica stocks from inside the castle. There are no longer costumed interpreters and I have heard that school visits are of lower priority. Perhaps, this is in response to falling budgets and thus decreases in staff, something that faces many heritage sites. More and more freelancers are being called upon to deliver a scaled down programme of activities. Whatever the reason, I find it sad to hear a castle described as 'not for families'.

How to interpret?
Once clear objectives and audiences have been established, you can begin to think about how to interpret - what methods and techniques to use. There are a whole array that will depend upon the objectives and outcomes for your project, from text panels and audio displays, to lighting projects and augmented reality. To remain relevant and professional, interpretation requires regular maintenance, including day-to-day cleaning, and refreshing every two to five years. The latter could involve

replacing faded panels or adding new films to audio visual displays, or it could involve installing something completely new. Careful consideration needs, therefore, to be given to the day-to-day management of interpretation, its practicality and robustness, and longevity. Audio visual screens displaying error messages, tired panels replaced or supplemented by in-house laminated A4 sheets, or empty children's activity stations in need of a good clean, are not only ineffective in terms of interpretation but reflect badly on an organisation. People expect a certain level of professionalism particularly if they are being asked to part with their money; this extends to leaflet displays, tea rooms and gift shops.

Effective interpretation must suit the place, the subject and the audience. Gimmicks should be avoided; I always follow the mantra, 'just because you can, doesn't mean you should.' For many years, new technologies have been embraced as a must have, particularly for younger audiences. More commonly today, parents and teachers suggest that because children are surrounded by the digital world, what they actually want/need is to experience more of the real world, and that more tactile hands-on activities are preferable.

Interpreters can sometimes be overwhelmed by the choice and do too much, as I feel was the case at Kensington Palace a few years ago. The Palace is managed by the Historic Royal Palaces who I had the pleasure of volunteering with whilst at University. I am always excited to see the interpretation at Hampton Court Palace and the Tower of London as they are highly experienced in appealing to dynamic multiple audiences. So I had high hopes when attending a course on interpretation at Kensington Palace in 2014. I was very disappointed, however. It seemed to me that an interpretation 'bomb' had gone off inside the rooms.

Every new technique had been used so that the story of the Palace, the sense of place was virtually lost on me. I watched as two ladies gazed at one of Queen Victoria's dresses. It was beautifully presented in a glass case; instead of labels it had a quote written across the front of the glass. This technique had been used everywhere, with quotes on the walls, carpet and even the ceiling! It felt cluttered, like a primary school classroom. The quote for the dress read 'it was the happiest day of my life'. One lady asked the other, 'is that her wedding dress then?' The other

answered, 'I guess so'. Then the first lady said as they walked on, 'I wonder when they got married'. Like them I was at a loss as to the purpose of the display, other than to look good.

Who gets it right?
I admit I do tend to be over critical as I expect most people are of the field they work in. Two places that I have visited stand out in my mind, Anglesey Abbey and Peterborough Museum. Anglesey Abbey (National Trust) recently redeveloped the kitchen areas with a very inclusive style of interpretation. Volunteers mix the last owner of the house's favourite cocktail, and cook real food from original recipes. There are store rooms and staff rooms set up as if the staff have just stepped outside. There are no barriers and people are encouraged to pick up objects, including a phone that rings intermittently in the hallway. We have been so conditioned not to touch though, only the brave actually answer it! Peterborough Museum has also recently redeveloped all its displays. They are very much aimed at family audiences so it might not suit everyone's tastes, but I would recommend popping into the original operating theatre.

Interpretation isn't an easy process, but if done right it should be an enjoyable and rewarding experience, which helps to connect the past, present and the future. *Brexit* and the desire for more Britishness, whatever that is, might lead people in this country to explore their heritage more readily looking for some sense of community and connectivity. Work in mental health and wellbeing is also looking at the role heritage can play in making positive change, again through connections and finding a sense of place, and perhaps, belonging.

I love heritage and interpretation, it is a professional field in which I greatly enjoy working and feel a great passion towards – a passion which I have always felt reflected in the following quote by Professor C. E. Merriam in Tilden's classic text:

> 'The underlying design is of course to set up a group of the living, the dead, and those who are yet unborn, a group of which the individual finds himself a part and of which he is in fact glad to count himself a member, and by virtue of that fact an individual of no mean importance in the world. All the great group victories he

shares in; all the great men are his companions in the bond of the group; all its sorrows are by construction his; all its hopes and dreams, realised and thwarted alike, are his. And thus he becomes although of humble status a great man, a member of a greater group; and his humble life is thus tinged with a glory it might not otherwise ever hope to achieve. He is lifted beyond and above himself into higher worlds where he walks with all his great ancestors, one of an illustrious group whose blood is in his veins and whose domain and reputation he proudly bears.'

Professor C.E. Merriam (in Tilden, 2007, 37).

References

Association for Heritage Interpretation 2017. *'What is Interpretation?'* Available at: http://www.ahi.org.uk/www/about/what_is_interpretation/ [Accessed 23/10/2017].

Mantell, O. 2017. 'Feature - Meaningful Segmentation.' The Audience Agency. Available at: http://www.theaudienceagency.org/insight/feature-meaningful-segmentation [Accessed 22/10/17].

Muir, J. n.d. 'John Muir Quote about Heart'. AZQuotes.Com. Available at: http://www.azquotes.com/author/10523-John_Muir/tag/heart [Accessed on 30/10/17].

Tilden, F. 2007. *Interpreting Our Heritage*. Fourth edition. Chapel Hill: The University of North Carolina Press.

Chapter Two

Some thoughts on Roman pottery and the role of women

Alice Lyons

Abstract
This chapter is an overview of the available evidence for female roles in the Roman Empire, and particularly Roman Britain, through the lens of ceramic analysis.

Introduction
It is the aim of this short chapter to review aspects of the available evidence to see if a female role can be discerned within the production and use of Roman pottery in the wider Roman Empire and particularly within the province of Britain. Roman culture, literature and pottery production and use are discussed.

Women in Roman Culture and Literature
The rich and much admired material culture of the Roman Empire, and the sources and dynamics of craft production, has long been an area of interest to the archaeologist (Strong and Brown 1976). The identity of the crafts people who made these objects and what their everyday lives entailed has not, however, been well recorded in what remains of the literary corpus. This is due in part to the structure of Roman culture where many skilled artisans were of low status or were slaves and as such were rarely individually recognised (Buckland *et al* 2001, 87). This poor representation is compounded for women, who although permitted to own their own property by Roman law, in a primarily patriarchal society were most often described in the literature by relation to the male head of the family: 'wife of', 'widow of', 'daughter of', 'mother of' (Allason-Jones 2005, 187-193).

It is not surprising therefore, that none of the 405 wooden Bloomberg tablets recently found in London, which are largely business correspondence and presently the earliest written records found in Britain (50-80AD), make any reference to women (Roger Tomlin pers. comm.). Happily, however, the Vindolanda tablets do provide a female voice in the form of a handwritten note by Claudia Severa inviting her sister (or friend) to her birthday celebrations, possibly the earliest surviving writing by a woman in Latin (*c.* 100AD; Tablet 291; *vindolanda.csad.ox.ac.uk/*). Another notable example of a woman in Roman literature is the Christian lady Melania, who lived in the early 5th century and is recorded as having held estates in Italy, Sicily, Spain, North Africa and Britain and is alleged to have owned 24,000 slaves (Finley 1980, 123). Both of these women, however, were educated and wealthy so would not have been personally concerned with the physical manufacture of commercial goods, particularly the lowly trade of pottery, although the latter may well have owned potteries.

It is usually both useful and advisable to look to Pliny the Elder for detailed descriptions of Roman life and although he does indeed mention the skill of potters and the success of their trade, notably the samian makers and, also a system of amphora apprenticeship, where gender is mentioned the pottery makers are all male ("a master and his pupil"; Plin. Nat 35:46). There is, however, a remarkable fresco fragment surviving from Pompeii which shows an image of a working Roman pottery and although the four potters shown (possibly a repeating scene) are clearly all male, a female assistant is present in the middle of the lower register (Fig. 2.1). This provides clear evidence for a woman working within a professional pottery – even if not in the role of potter (Peña & McCallum 2009, 61, fig. 4).

Women and Pottery Production

Potter's stamps: As literary references are scant and the pictorial evidence limited, considering the evidence of pottery that was regularly stamped by its maker, such as samian (Tyers 1996, 105-116) and mortaria (*ibid*, 117-135) seemed like the next logical step in exploring production and gender. Previous research on the related subject of tile stamps suggests as many as 30% of the brickyard owners and 6% of the officinators (meaning tenant or manager) in central Italy were women

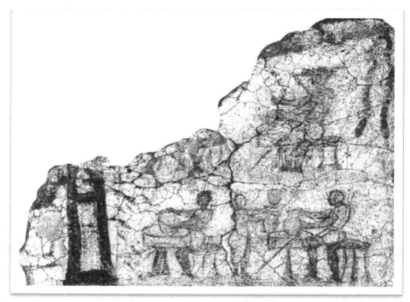

Fig. 2.1. Pompeii: Fresco depicting four potters and a female assistant from Hospitium dei Pulcinella (© Soprintendenza Archeologica di Pompei).

(Helen 1975, 112-113). One such example is the Domitiae Lucillae (mother and daughter) who inherited tileries, although it is not known how active their involvement would have been. While Aubert (1994) used pottery stamp evidence to suggest women potters (*ibid*, 292, endnote 316) and managers (*ibid*, 293, endnote 318) were not 'so exceptional', going on to quote the great legal authority Ulpianus (*c*. 170-223AD) who wrote in reference to tilery contracts 'it matters little who is business manager, whether it is a man or a woman, a free person or a slave…'.

Unfortunately, the potters' makers stamps often use an abbreviated name which confuses matters of gender, as while it is normal for Roman Latin female names to end in an 'a', this can also occur in masculine abbreviates. Celtic names ending in 'a' can be male; this is also relevant when analysing graffiti (see below). So while some stamps can be interpreted as female, others such as the Gaulish samian stamps which could potentially hint at women makers, such as Belsa who worked in Lezoux between 160-200AD and Biga, have conventionally been interpreted as abbreviated male names (Hartley and Dickinson 2008). Accepting this evidence, it seems that in the ceramic industries of the

greater Roman Empire (Italy and Gaul) while the majority of managers and potters were men, women were not unknown or even unusual. In the province of Britain, however, the stamps of women potters' have yet to be identified.

An area of ongoing research that may reveal the true extent of women in pottery production are the fingerprints left in the surface of these vessels (often in applied slips) the small size of which indicates both women and children were employed in at least part of the pottery production process (Thompson n.d.).

Evidence from graffiti: Pottery was not only formally stamped by its makers, it was also used as a surface to write upon – so what can graffiti tell us about the role of women in pottery manufacture?

One graffito particularly worthy of note was found on a Gaulish samian vessel from La Graufesenque, where a work list had been inscribed into the surface of the pot before it was fired (Marichal 1988, No. 169). It records that Agileius, one of six slaves of a woman named Atelia, worked for fourteen days preparing clay between late June and late July. The implication is that Agileius was hired by the potter Cosius Rufinus from the owner of the villa estate, Atelia (Hartley and Dickinson 2008, 22).

Another graffito, this one on a mortarium from Brockley Hill north of London, was initially thought to be that of a woman potter named 'Catia Maria', although Kay Hartley later proved this to be an incised copy of the stamp used by the male potter 'C Attius Marinus' (Allason Jones 2005, 74). While other examples of graffito associated with women and pottery production are not presently known, there are numerous examples of female names etched into both samian [1] and coarse wares[2], which indicate ownership and use.

[1] RIB II.7, 2501 (samian): 41, ALBINA; 48, AMA(N)DA; 92, AVRELIA; 117, 118, CANDIDA; 128, CARINA; 166, DVBITATA; 177, FAVSTA; 178, FELICVLA; 238, [ING]ENVA; 291, LIBERA; 362, MATRONA; 390, MINICA; 533, TVNGRA. Supplied by R. Tomlin
[2] RIB II.8, 2503 (coarseware): 177, ALATVCCA; 209, BELLA; 219, CANDIDA; 240, DECMA; 244, DISETA; 296, IVNIA; 335, MATVGENA; 376, PEREGRINA' 382, POSTIMIA; 411, SENNA; 412, SENTICA; 460, VITIA. Supplied by R. Tomlin

Tomlin (1997) has published a particularly interesting graffito example from Carlisle which shows the name 'Marica' etched into the base of a samian dish around the head of a beautifully inscribed (but not species specific) bird. 'Marica', interpreted as probably a female Celtic personal name, may have been an immigrant from Noricum (modern Austria and part of Slovenia) or its vicinity. It is not known how she and the bird were connected, but one theory is that it may have been a play on her name or character. Other notable graffiti include a 'common vessel' shared by seven persons, one of whom was a woman[3] and another which apparently associates a dancer named VERECVNDA with a gladiator[4].

The Cult of 'Head Pots'

Whilst the hints at the everyday lives of Roman women scratched into the surface of pots are very evocative I do not want to leave this quick review of the relationship between the female and the ceramic without mentioning the cult of the 'head pot'. Despite women being frequently decoratively depicted on Roman pottery vessels, often in erotic contexts (Howe *et al* 1980, 16, fig. 3, no 28) and possibly with important superstitious and cult connections (de la Bédoyère 2013, 251, pl. 243), it is only with the introduction of the head pot that the female becomes the sole focus of the vessel form.

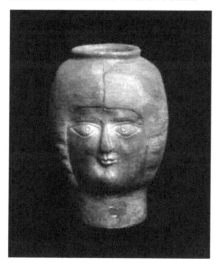

The history of head pots is long and they had been known in Britain since the conquest in 43AD (Braithwaite 2007, 237-238). During the 3rd century AD, however, a very distinctive pot showing a venerated female form became popular in York (Fig. 2.2). The introduction of this particular form of head pot appears to be contemporary with the visit to

Figure 2.2. Large head vase from York in fine burnished red ware. Yorkshire Museum, York; 3rd century AD; height 30cm (Braithwaite 2007, Pl. S12, 448).

[3] RIB II.7, 2501.307. Supplied by R. Tomlin
[4] RIB II.7, 2501.586. Supplied by R. Tomlin

York of the African Emperor, Septimius Severus, and it is proposed that they were first made in the city by potters from North Africa around 211-12 AD (Swan and Monaghan 1993, 21-38). The hairstyle and facial details suggest that it is modelled on Severus' Syrian wife, Julia Domna (Fig. 2.3), who accompanied him on his visit to York. If this theory is correct we may have a portrait pot (if idealised) of a real Roman woman. It is of particular interest that this form of head pot has no obvious close counterparts anywhere else in the Roman Empire (except perhaps in North Africa) and as such it seems to be a British provincial idiosyncrasy.

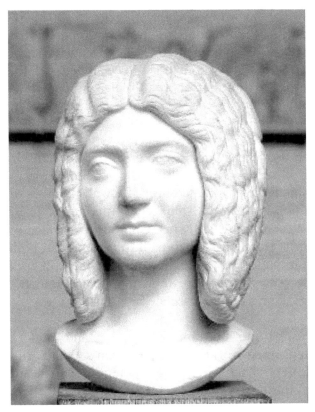

Figure 2.3. Bust of Empress Julia Domna ca. 200 AD. Munich, Germany.

It is worthy of note, that the head pot tradition, particularly in the vicinity of Hadrian's wall, continued to develop into the later Roman period where anthropological vessels were made celebrating the female face and form, perhaps copying more expensive and not as readily available metal vessels for use in religious practices (Braithwaite 2007, 305). This fashion for female 'face pots', rather than whole head pots developed, so by the 4th century AD their use had spread across the province of Britain, where they formed part of the normal repertoire of several of the large regional pottery industries based around Oxford (Tyers 1996, 176, plate 219, no C11.4) and the Nene Valley (Howe *et al* 1980, p26, fig. 8, no 96).

These face pots are also known in west Norfolk, such as the Nene Valley example from Hockwold-cum-Wilton (Gurney 1986, 78-79, fig 49, no.98) and the fine fired clay moulded female face, probably intended to become part of a pot, found at the Roman Saxon shore fort in Brancaster (Sparey Green and Hinchliffe 1985, 58, fig 39, no 132).

Before the Roman period pottery production and use had been known for several thousand years. During prehistory pottery was produced by hand on a small scale when it is assumed almost certainly correctly (with ethno archaeological support (Peacock 1982) that most pots would have been made by women as part of their household routine (Tyers 1996, 33-35, table 10). Whilst in many parts of the Roman Britain these domestic Iron Age production practices may have continued for a significant time, as pottery manufacture became commercial and took place outside of the domestic realm, it seems that it fell into the sphere of men – at least in its administration and distribution.

Conclusions
There can be little doubt then that women played an essential role both in the manufacture and use of pottery in Roman life. The practical role of women in Roman pottery manufacture is hinted at in the wall painting of Pompeii, in some Italian pottery stamps and legal literature. Their physical trace can be seen in fingerprints still surviving on the surface of pots - whilst the female form is frequently celebrated in ceramics in both decorative motifs and the widespread use of idealised female faces in both head and face pots. Female pottery users are remembered in women's names scratched in to the very fabric of the vessels.

Despite this evidence it seems the question of gender and pottery manufacture (and use), in the Roman world has not yet been satisfactorily concluded, or even that widely discussed. Much potential exists for identifying Roman women through ceramic analysis, in the Roman province of Britain, and indeed, even in West Norfolk with its local kiln production sites, such as Pentney and its rich and well dated excavated assemblages. Perhaps the continued and expanding interest in gender politics, combined with scientific advances may make identifying the female both desirable and possible.

Acknowledgements

When Clive kindly asked me to contribute to this volume (at short notice!) I sent out three emails to some very knowledgeable colleagues who all provided thoughtful and detailed replies without which this work could not have been written, so my sincere thanks are extended to: Dr. Roger Tomlin (Fellow, Wolfson College, Oxford), Kay Hartley (freelance mortarium specialist) and Dr. Gwladys Monteil (freelance samian specialist). Thanks are also extended to Sarah Percival (freelance prehistoric pottery specialist) and Dr. Joanne Clarke (Senior Lecturer, School of Art, Media and American Studies, UEA) for their thoughts on the draft text.

References

Allason-Jones. L. 2005. *Women in Roman Britain*. York: Council for British Archaeology.

Aubert, J-J. 1994. 'Business Managers in Ancient Rome. A social and Economic Study of Institutes 200 BC-AD250'. *Columbia Studies in the Classical Tradition*, Vol XXI.

Braithwaite, G. 2007. *Faces from the Past: A Study of the Roman Face Pots from Italy and the Western Provinces of the Roman Empire*, BAR International Series 1651

Buckland, P. C., Hartley, K. F., and Rigby, V. 2001. 'The Roman Pottery Kilns at Rossington Bridge Excavations 1956-1961'. *Journal of Roman Pottery Studies*, Volume 9.

de la Bédoyère, G. 2013. *Roman Britain, A new History*. London: Thames and Hudson.

Finley, M. I. 1980. *Ancient Slavery and modern ideology*. London: The Viking Press.

Gurney, D. 1986. *Settlement, Religion and Industry on the Roman Fen-edge, Norfolk*. Dereham: East Anglian Archaeology 31.

Hartley, B. R. and Dickinson, B. M. 2008-12. *Names on Terra Sigillata: an index of makers' stamps & signatures on Gallo-Roman terra sigillata (samian ware).* London: Institute of Classical Studies, 8 vols.

Howe, M. D, Perrin, J. R., and Mackreth, D. F. 1980. *Roman Pottery from the Nene Valley: A guide.* Peterborough: Peterborough City Museum and Art Gallery.

Marichal, R. 1988. *Les graffites de La Graufesenque*, Gallia, Suppl.47.

Peacock, D. P. S. 1982, *Pottery in the Roman world: an ethnoarchaeological approach*, Longman archaeology series. London: Longman.

Peña, J, T., and McCallum, M. 2009. 'The Production and Distribution of Pottery at Pompeii: A Review of the Evidence; Part 1, Production'. *American Journal of Archaeology*, Vol. 113, No. 1, 57-79.

Sparey Green, C. and Hinchliffe, J. 1985. 'Objects of fired clay', 58-62. In Hinchliffe, J with Sparey Green, C., *Excavations at Brancaster 1974 and 1977.* Dereham: East Anglian Archaeology 23.

Strong, D., and Brown, D. (eds.). 1976. *Roman Crafts.* New York: New York University Press.

Swan, V., and Monaghan, J. 1993. 'Head-pots: a North African tradition in Roman York'. *Yorkshire Archaeology Journal* 65, 21-38.

Helen, T. 1975. *Organization of Roman Brick Production in the first and second centuries AD.* Annales Academiae Scientiarum Fennicae. Dissertations Humanarum Litterarum 5.

Tomlin, R., 1997. 'Property of Marica' *Britannia* 28, 461-2, No. 20.

Thompson, C., n.d. *Fingerprints on samian.* Unpublished MA thesis. London: Institute of Archaeology, University College London.

Tyers, P. 1996. *Roman Pottery in Britain.* London: Batsford.

Chapter Three

Tilney All Saints – A venture into Archaeology

June Mitchell

Abstract
This chapter will focus on the experiences of a local group of residents as they launched into archaeology with a test pit programme in the village of Tilney All Saints, West Norfolk, and the investigations at Bury Manor.

Introduction
Tilney All Saints is one of the 'seven Marshland towns' shown, with its Church and settlements, on sixteenth century maps of Norfolk. It is small, with about two hundred and fifty households, but scattered widely geographically. When new residents moved in, they found very little to answer questions concerning the history of the ancient parish. I was one of the 'newbie's' in the year 2000, and with my husband, and a few longer-term residents, set in motion a group to research and record the village history. The *Tilney All Saints Local History Group* was officially formed in 2006 (Tilney All Saints Local History Group 2017). I had recently retired from a nursing career, and became the first Chairman of the Group.

The Tilney All Saints Local History Group and Archaeology
A huge learning period ensued on 'How to…' sessions. For, instance – 'how to…' research local history; write local history; publish local history. With, enthusiasm, perseverance, and helpful books, the group's first book was published in 2008. In 2013, a Group member (and a woman) suggested archaeology was something new for the Group to do, and another major learning curve began!

By this time, I was secretary and organiser, and invited the Community Archaeologist (Community Archaeologist, Norfolk Historic Environment

Service, Norfolk County Council) to visit. Considerable interest was shown with about fifteen attending the talk, and resulting in a keen enthusiasm to embark on a programme of test-pitting. As far as the secretary was concerned there was just one problem – that the local group would be expected to organise and manage the programme. This included: recruitment of volunteers; organising host locations for the excavations; processing any finds recovered. However, the support and advice of the Community Archaeologist would be available.

Publicity in the village news magazine provided offers for hosting, and a few new people volunteered for the project. A new Community Archaeologist had been appointed: Claire Bradshaw. So, arrangements were made for a training session with Claire and her students, and the local volunteers at Chase Fruit Farm. Two test pits were excavated under supervision and Claire took the bagged and labelled finds to Gressenhall, East Dereham the headquarters for the Norfolk Historic Environment Service for identification. With this, and subsequent test pit excavations in 2013, the Group were beginning to identify the medieval pottery sherds which were found in most pits, and even the odd Saxon sherd. The Group valued and remained dependent on Claire's support throughout the 'dig' campaigns of 2013-15 (Fig. 3.1).

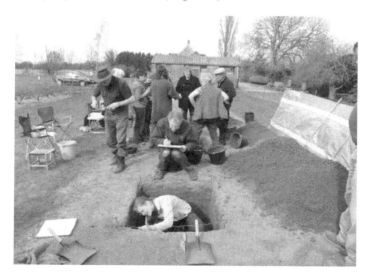

Figure 3.1. A 1m x 1m test pit being excavated by members of the *Tilney All Saints Local History Group, under the supervision of* Claire Bradshaw, the Community Archaeologist in April 2013. Claire is in the centre, background, facing away from the camera (© June Mitchell 2013).

Excavations at Bury Manor

Two of the test-pits took place at an old ruin, known as Bury Manor, which is hidden away by overgrown jungle, and surrounded by crop fields. A survey of the evidence for the manor was completed by the then, Historic Environment Record Officer, Edwin Rose, in 2005 (see NHER 2017). The study suggested the manor dated from sixteenth century, but the present building is largely eighteenth. The house had been allowed to fall into ruins when the last occupant moved out, circa 1962. The results of the excavations were interesting, but someone (a woman) suggested it would be more interesting to dig *inside*. At the time (2013) access to the interior was barred with mature trees and bushes, but the farmer among us, said they could be cut down. Permission from the owners was sought and given, and he sent a JCB digger to cut down an access to the building. Since then, a small group have continued to remove the four feet of rubble, bricks, roof tiles, earth, and chimney pot pieces that had fallen into the rooms. Five units have been cleared to top floor level (Fig. 3.2).

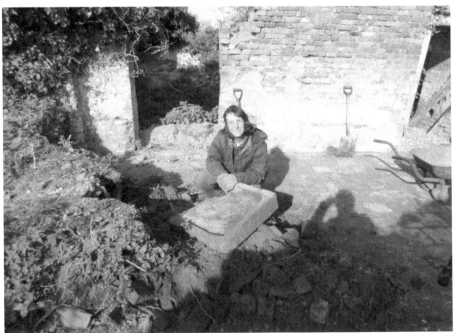

Figure 3.2. Mrs. Phil Perry beside a 1m x 1m test pit in the extant ruins of Bury Manor, 10th October 2017. She's excavated half of a stone sink at Bury Manor; the other half had been found some month before (© June Mitchell 2013).

Fireplaces have been discovered and internal dividing walls of beams and bricks, and tiled floors. Beneath the top floors, small excavations have shown two further floor levels. Two further rooms/units have now been cleared. These were thought to be extensions to the main building, but the final room is possibly telling a different story. In the nineteenth and twentieth century occupation of the house, one of the rooms was a kitchen with early range, stone sink and typical household goods of early twentieth century discovered.

Conclusions

The final room is nearing completion, excavation down to top floor level. This means it will soon be possible to excavate further to search for evidence of the earlier building, or buildings at Bury Manor. Then there are the barns and the gatehouse to explore! At 78 this year, this woman in archaeology might just be leaving this to others.

References

NHER 2017:

Norfolk Historic Environment Record 2017. *'NHER No.: 42014 – Ruins of Bury Manor, Tilney All Saints'.* Norfolk Heritage Explorer www. Available at:
http://www.heritage.norfolk.gov.uk/record-details?MNF47131-Ruins-of-Bury-Manor-Tilney-All-Saints&Index=40053&RecordCount=56734 [Accessed on 30/10/17].

Tilney All Saints Local History Group 2008. *Tilney All Saints in Living Memory.* Tilney All Saints: Tilney All Saints Local History Group.

Tilney All Saints Local History Group 2017. *The Tilney History Group.* Available at:
http://www.tilneyallsaintsonline.org.uk/ [Accessed on 30/10/17].

Chapter Four

A Topographical Survey of a Medieval Moated Manorial Site, North-East of Miller's Farm, Hilgay, Norfolk 2015

Alvina De-La-Mare

Abstract

This chapter provides the method and results of a limited topographical and earthwork condition survey of a moated site (NHER 4454), north-east on the Hilgay island. The survey was used as a training exercise for volunteers but also updated elements of a topographical survey completed in 1999.

Introduction

An earthwork and moated site situated in the north-east corner of Hilgay, Norfolk, was surveyed in June 2015 by a group of volunteers and members of West Norfolk and King's Lynn Archaeological Society (Fig. 4.1). This targeted fieldwork, was part of the 'Ouse Washes Landscape Partnership Community Archaeology (Norfolk)', funded by the Heritage Lottery Fund, to enable heritage and archaeology skills to be taught in the west Norfolk parish of Hilgay (Bond 2015).

Aims and Objectives

The aim of the survey was to establish whether earthworks in pasture to the north of Thistle Hill Road, Hilgay had changed in size or shape or condition since they were last surveyed in 1999 by Cushion and Davison (2003, 109, fig. 72). In that survey no profile of the ditch of the moat was recorded; this exercise gave an opportunity to add to the data in that survey. A key objective was to record any signs of erosion or alteration to the site's condition and provide a record of a series of transects of the moated ditch profile. This limited fieldwork, completed over one day, Sunday 7th June 2015, would also provide a small group of volunteers training in topographical survey.

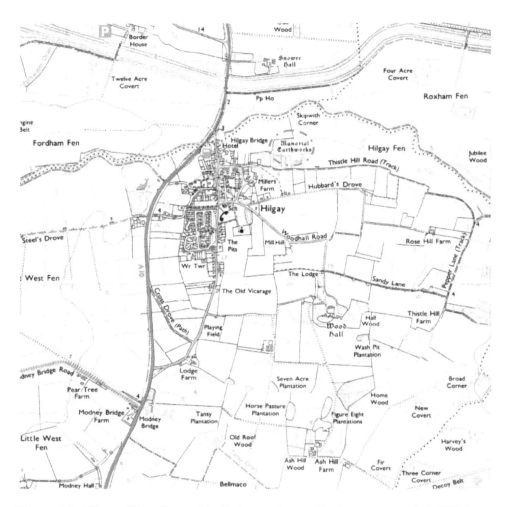

Figure 4.1. Hilgay village featured in Ordnance Survey Explorer map, scale 1:25000. The moated site is illustrated with hachures at north east of village (OS © Crown copyright 2015 FL-GV100044755).

Due to time constraints, the availability of equipment, and the learning environment necessary for volunteers to engage with the task, the emphasis of the fieldwork was one earthwork, a moat, rather than any other topographic feature part of this known complex (Cushion and Davison 2003, e.g. nos. 2-7 in fig. 72).

Background

The earthworks have been designated a scheduled monument since 1976 (Historic England 2015: National List No. 1020345) and have remained undisturbed within farm pasture for many years. Though generally assumed to be the site of a medieval manor farming fish (Silvester 1991, 46-47, plate IV), documentation of the specific use and history of the site is elusive. The Norfolk Heritage Explorer chronicles visual and physical characteristics of the site's preservation from 1946 to 1999, but can only postulate its likely existence as a manorial complex with links to Ramsey Abbey (Norfolk Heritage Explorer 2015: Norfolk Historic Environment Record No. 4454; Historic England 2015: National List No. 1020345). In 1999 Cushion and Davison carried out a full survey of the monument, noting finds and features, and it is their hachure plan which guided us in this survey as the only detailed illustration of the full site available (Cushion and Davison 2003, no.1 in fig. 72). A more detailed statement on the historical cartographic and aerial photograph record is provided in the Appendix.

Methodology

Three methods have been applied to this moated earthwork:

- Drone aerial survey
- Walkover condition survey
- Tape measure off-set survey and optical sight survey.

Drone Aerial Survey: The small and agile remote-controlled drone with stabilised digital camera feature was launched from adjacent the site. In-field this was operated by Mr. Kevin Elfleet. The drone aerial survey produced vertical and oblique images of the site, though unfortunately without a true scale (Fig. 4.2). In Figure 4.2, below, the main manor house platform is clearly defined, along with vegetation encroaching on the drying moat. Small pale brown spots peppering especially the north side of the platform are molehills. The track running down on the left is Thistle Hill Road; Hilgay Village main lies to the west and south of the site.

Interpretation of vertical images: Overall, the site was considered to be in good condition, with main features still visible, but note was taken of the profusion of mole hills which will have disturbed much of the earth beneath and mixed stratification layers; pieces of pottery at the surface of

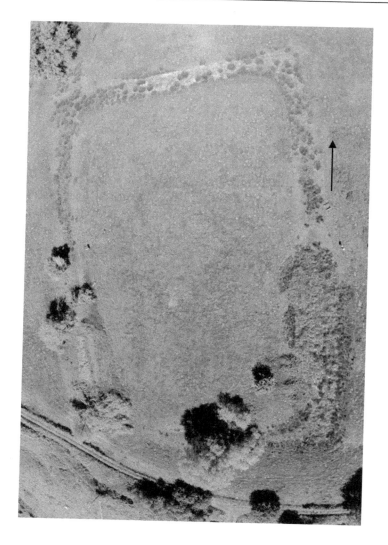

Figure 4.2. Aerial photograph of the moated manor house platform, taken using a drone Arrow, is pointing North, top right of photograph (© Kevin Elfleet 2015).

molehills were numerous. Though essentially dry, soil at the base of ditches remains damp and boggy, allowing reeds and rushes to continue to flourish. Several trees are also well-established along the base of the moat furthest from the river, but these include types like willow which will withstand regular flooding and damp sites. These trees are visible in

the 1946 RAF aerial photograph of the site, and they are even suggested in similar position on the Ordnance Survey 1880s first edition map including the site (see Appendix).

Walkover condition survey: The small group of volunteers completed a walkover of the site to observe the shape of earthwork, following the 1999 Cushion and Davison hachure plan (Fig. 4.3). Detected areas of erosions by animal grazing, walking, or human intervention, such vehicle use, were photographed with scale poles, and their causes speculated upon. Locations were sketched onto a copy of the 1991 plan and a handheld Global Positions System (GPS) coordinate was taken.

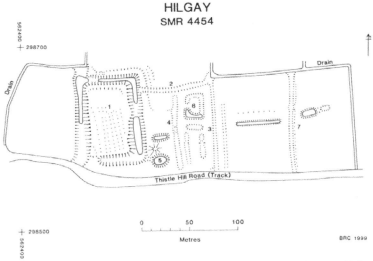

Figure 4.3. Plan of moated site with extensive fishponds, surveyed 1999 (After Cushion and Davison 2003, fig. 72).

Tape Measure Off-set Survey and Optical Sight Survey: No obvious baseline or in-field feature was available, to act as a point of reference, save a hedge boundary. So, a 100 metre tape measure was laid out as a baseline. This was set up along the western outer edge of the moat, measuring 94.4m from each hedge bordering the field adjacent to the moated site. From a near central point of 40m, a 90° angle was off-set to measure across an eroded point of the moat. The same measurements were completed at 20m to compare with the 40m points recorded earlier.

Using an optical sight or 'dumpy level', measurements of the depth of the western arm of the moat and its sides were taken and recorded in the field (Fig. 4.4). This baseline plan with notes for each tripod location would provide first-hand reference for the later plotting of the ditch/earthwork profiles. Handheld GPS locations of baseline off-sets were also noted, to ensure measurements were securely located spatially across the site.

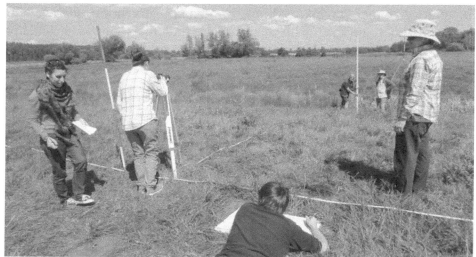

Figure 4.4. Volunteers taking and recording readings from a 'dumpy level' across the western arm of the moat (© Clive Bond 2015).

Results and interpretation

The drone aerial survey provided some good clear photographs of the overall site which we are able to compare with modern and historical aerial photographs, observing similarities and changes. Whilst the shapes of the moat and accompanying fishpond features have been visible in aerial photographs from 1946, 1988, and recent satellite imagery (see Appendix), the drone was able to focus much closer and reveal details such as the extent of encroaching vegetation, worn pathways and erosion, even molehills. This may prove valuable source for future surveys and observations of the site, its changing condition over time.

When compared with the 1999 plan of the site (see Figs. 4.3 and 4.5) it is interesting to note that the parts of the moat shown to still hold water appear on the aerial photograph with low-lying marsh plants and without

trees. Small hachure marks in the centre of the manor house platform delineate darker patches of grass in the photograph, perhaps interpreting the actual site of the manor house – though vegetation on top of stone remains would be presumed to grow more thinly due to obstructions in the soil preventing access to richer moister earth.

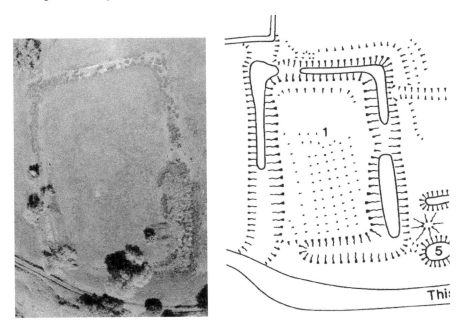

Figure 4.5. Aerial photograph of the moat (taken by drone 7/6/15) compared with Cushion and Davison's 1999 plan (Extract after Cushion and Davison 2003, fig. 72).

Below, Figure 4.6 produced from the two points of measurement across the western arm of the moat demonstrate that, despite surface appearances, depths remain fairly consistent between the first path of erosion (Tripod 1 at 40m) and the overgrown point (Tripod 2 at 20m). Section plans of each ditch profile overlap one another closely, although the line associated with Tripod 1 is deeper either side of the line drawn from Tripod 2, where the bottom of the moat is discerned, suggesting widening and extra wear from use as a pathway. The shallow 'U' formation confirms the moat was excavated during the Middle Ages and is an ideal shape to hold water, compared to earlier V-shaped moats (Le Patourel 1978).

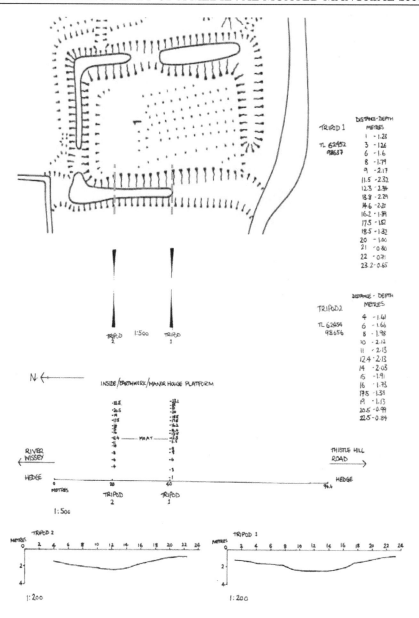

Figure 4.6. Top left: Extract from 1999 survey plan (Cushion and Davison 2003, no. 1 in fig. 72) set in line with hachures (below) based on measurements taken at Tripods 1 and 2. Centre right: Tripod and measured transect data in metres. Bottom: Profile sections of moat ditch. Each, profile demonstrates differences in shape between the two Tripod points.

This data could provide information to update the 1999 hachure survey of Cushion and Davison. Two hachure sets able to be plotted from this information are necessarily isolated in terms of the whole site, but more measurements taken all around the moat would start to build up a wider picture able to be compared closely with the 1999 plan. Care taken over the specific forms hachures take to convey steepness and shape would also contribute to observations of changes in condition (Bowden 2006). Yet hachures, though excellent at demonstrating a broad view of a site and helping to distinguish the shapes of features one might expect when walking over it, do not communicate real information like the exact depth or width of an earthwork – information that would help to monitor the site's condition in small phases and possibly lead to preventative measures against damage, rather than reaction too late.

Discussion

As a scheduled monument, the site has not received recorded maintenance to ensure its preservation, but has been monitored over time within very rough ten year intervals; brief reports of site visits are attached to the Norfolk Heritage Explorer site record 4454. Historic England's summary of the monument – last amended in 1998 – describes the moat, '…which ranges from 10m to about 17m in width and remains open to a depth of up to 1.5m' (Historic England 2015:National List No. 1020345). If these measurements are taken to be accurate, the present measurements presented here as part of this survey give approximately 22m to 23m across a small section. Even allowing for extra overlap at the outer edges, these survey results are much higher! The team's optical sight's readings for the base of the moat (2.13m to 2.34m) fit in better with the previous 1.5m depth. The appearance of the moat on the ground is of fairly even sides and it is hard to conceive that the ditch walls would have expanded so regularly along the whole length by about 3m in seventeen years, between the two surveys. Yet all measurements here must be taken as very approximate; it can be difficult to define precisely where an earthwork begins or ends when slopes on rough ground are to be measured. Perhaps the team's measurements were overgenerous, or the 1999 measurements were conservative. Moreover, allowance should be made, to some degree for the conditions during survey: summer – grass length and other shrubs etc.

The signs of erosion recorded on the day have been located on the aerial photograph of the moat (Fig. 4.7). Within Figure 4.7, insert images 1, 4, 5, 6a and 6b are in keeping with people and livestock making obvious access paths across the land, whilst 6a and 6b also show evidence of a trackway for tractors and vehicles. Insert images 2 and 3 mark places at the bottom of ditches that may demonstrate the effects of livestock grazing and travelling across the large site. Alternatively, as the site is still liable to seasonal flooding and the bases of the ditches are still boggy in places, the erosion and widening shown at the corner point 2 could be due to water flow. The sandy silty soil in this stretch of land between Hilgay island and the River Wissey may also be subject to slipping and erosion from plant roots and natural weathering.

The area we were able to cover was very small in comparison to the whole site, due to the nature of working with volunteers who needed guidance in setting up and operating the equipment to archaeological criteria, and in recording results accurately. However, the close attention that was paid to our methods and the guidance by the team's director meant we worked well together to truly understand what we were doing and how to interpret our findings. Future surveys may therefore be undertaken with more confidence and accomplish more in the time allocated.

Conclusions

The last survey of this site in 1999 (Cushion and Davison 2003, no. 1 in fig. 72) produced a hachure plan at the scale 1:2500. Despite descriptions of the site and local area in both Cushion and Davison (2003, 109) and Silvester (1991, 46-47, fig. 27, plate IV), there are no close measurements of the height of the earthworks in the field. This is important – no detailed illustration indicates the experience, or actual measured height/depth of the moat on the ground. The 1999 hachure plan (Cushion and Davison 2003) marks out still definable earthworks, but at such a small scale it is difficult to compare with our present survey and observations.

The earthworks seem resilient – they have long been noted on maps and are still very obvious to the field walker – but the slow progress of erosion by livestock and humans, and the underground machinations of moles are changing their landscape irrevocably. Our survey (the first in

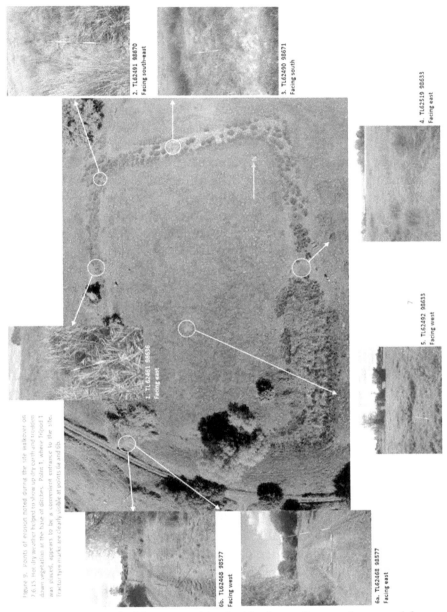

Figure 4.7. Drone survey vertical image combined with observations on the ground from the walkover survey assessing the earthwork condition (After De-La-Mare 2015, figure 9).

16 years), however tightly focused, serves as an important record of observations to help perpetuate the monument's documentation. With more fieldwork, it could provide detailed findings to ensure future surveys more closely monitor changes in conditions and, if not act to restore damaged areas, at least carefully document any decline.

Acknowledgements
Thanks are due to Rob Martin of Hilgay for enabling access to his farmland, on Miller's Farm, Hilgay; Dr. Clive Bond (survey and project director) for organising the programme of community outreach events, providing archaeological equipment, and supervising volunteers conducting the survey; Kevin Elfleet for flying the drone and securing the vertical images; Edward Cumbley and Ciara Furlong (work placement officers with the project) who made on-site plans of the survey; the Ouse Washes Landscape Partnership for providing funding for this project via their small-grant Heritage Lottery Funded scheme; volunteers of the West Norfolk and King's Lynn Archaeological Society. Further details of the 'Ouse Washes Landscape Partnership Community Archaeology (Norfolk) can be found at www.greyhawk.org.uk/fenedge/main.php

Note: mapped Ordnance Survey data has been utilised whilst studying at the Institute for Continuing Education, the University of Cambridge (Digital data source: an Ordnance Survey/EDINA supplied Service). Map images have also been accessed via a public domain: Norfolk County Council's *Historic Maps* www.historic-maps.norfolk.gov.uk/

Appendix

Cartographic and Aerial Photographic Evidence
Hilgay is a Norfolk village approximately four miles south of the town of Downham Market and approximately fifteen miles north of the Cambridgeshire town of Ely. Like its surrounding fenland, Hilgay stands on an island of Kimmeridge clay bordered by a channel of peat where the River Wissey now flows. This higher ground is overlain with cretaceous greensand upon which is a layer of sandy soil containing flints, informing the settlement's largely agricultural occupation (Shaw 2009; Silvester 1991, 45-47). The River Wissey branches off from The Great Ouse, two and a half miles west of Hilgay, and flows across and around the top of

the island, providing the water source to feed our moated site and its extensive fishponds.

Moats on such mediaeval sites were usually symbols denoting the standing of the residents (Historic England 2015: National List No.1020345). Here, like many of its kind, the moat was not in any way a military defence structure but, considering its position on low ground so close to the river, may have served some purpose in deflecting flood waters around the manor house and redirecting water to the extensive fish ponds and channels to its east. The extent of the fishery does support the theory that this was a successful enterprise, however, so the moated house would be a fitting representation of wealth and prestige.

The manor site is close to the river but, unusually, a distinct distance from the church in Hilgay, at a time when manors would usually have been built close to the church for the privileged occupants' personal use. Wood Hall, a manor positioned approximately a mile and a half out from the main village is also some distance from the church. This indicates Hilgay may have been a larger settlement in the past.

Snowre Hall sits across the River Wissey and the present day Cut-Off Channel almost exactly opposite our moated manor site. Snowre Hall had strong links to Hilgay in the Middle Ages, and came under the jurisdiction of Ramsey Abbey. St Mary's Abbey, established 1188, lies across the river a short distance north east of Hilgay but is not mentioned in any connection with Hilgay or Ramsey.

Hilgay's island formation has been noted on maps from 1797 through to 1836 (Faden 1797; Bryant 1826; Ordnance Survey 1824-1836).

Faden 1797

Bryant 1826

Ordnance Survey 1824-1836

Closer range maps do outline the specific site of the 'manorial complex' – on Ordnance Survey's 1880s first edition and its 1928 edition – but these simply outline the space occupied without any illustration of the earthworks within.

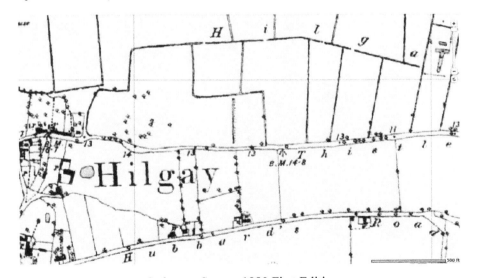

Ordnance Survey 1880 First Edition.

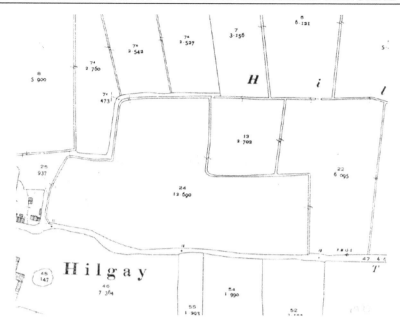

Ordnance Survey 1928.

The current Ordnance Survey Landranger map (1:50,000) shows the island of Hilgay through contour lines and marks the presence of the moated site with the symbol for a 'Site of Antiquity' and the caption 'Manorial Earthworks', whilst the current Explorer 1:25,000 map uses small hachures to indicate the general shape of the moated site's embankments.

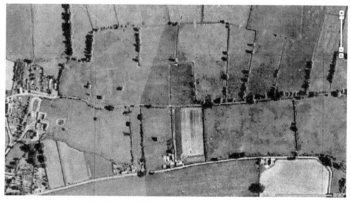

RAF aerial photograph, 1946.

In 1959 the site was flooded, along with many settlements near to the Ouse; the moat and fishpond features were immortalised in an RAF aerial photograph from January of that year.

References

Bond, C. J. 2015. *Ouse Washes Landscape Partnership Community Archaeology (Norfolk)*. Unpublished project bid. King's Lynn: West Norfolk and King's Lynn Archaeological Society.

Bowden, M. 2006. *Unravelling the Landscape: An Inquisitive Approach to Archaeology*. Stroud: Tempus.

Cushion, B. and Davison, A. 2003. *Earthworks of Norfolk*. Dereham: East Anglian Archaeology No.104.

De-La-Mare, A. 2015. *'Topographical survey of medieval moated manor north-east of Miller's Farm, Hilgay, Norfolk'*. Unpublished Assignment No. 1415DCR801 submitted for part completion of the Undergraduate Diploma in Archaeology. Cambridge: Institute for Continuing Education, the University of Cambridge.

Historic England 2015. *National List Entry: Moated site and associated earthworks 270m north east of Millers Farm, Hilgay Scheduled Monument/National List No. 1020345*. Available at: www. historicengland.org.uk/listing/the-list/list-entry/1020345 [Accessed on 12/06/15].

Le Patourel, H. E. J. 1978. 'The Excavation of Moated Sites', 36-45. In Aberg, F. A. (ed.), *Medieval Moated Sites*. York: Council for British Archaeology Research Report No. 17.

Norfolk Heritage Explorer 2015. *Norfolk Historic Environment Record No. 4454*. Available at: www.heritage.norfolk.gov.uk/ecord-details?mnf4454 [Accessed on 12/06/15].

Shaw, C. 2009. *Fordham, Hilgay & Ten Mile Bank, Little Ouse, Ryston & Roxham, Southery: A brief history for local and family historians*.

Silvester, R. J. 1991. *The Fenland Project, Number 4: Norfolk Survey, The Wissey Embayment & Fen Causeway*. Dereham: East Anglian Archaeology No.52.

Chapter Five

Making Pottery from the Past in the Present

Kate Phillips

Abstract
This brief chapter discusses the making of ancient pottery technology, in the present, either for museum displays, or replica pieces for re-enactor groups. I reflect on my practice as a potter and women.

Introduction
As a professional potter I have been making pottery for over twelve years. I've worked on recreating ceramic technology – pottery ranging from Prehistoric, through to the Tudor period for re-enactors, museums, exhibitions and television documentaries. Recent commissions have included Birmingham University, BBC North, the British Museum, the Jorvik Centre in York and The Royal Shakespeare Trust (see Appendix).

Making Ancient Pottery in the Present
All the pottery is made as accurately as possible from historical reference material (Fig. 5.1, 5.2 and 5.3). Indeed, in most cases my research consists of sourcing published archaeological reports, other documentation and museum archives. This gives each pot, a discrete level of historical accuracy, authenticity, and each pot has its provenance.

Replica pots for museums and places of learning are made as closely as possible to the original pots in design, the clay used, and the firing method. For re-enactors the pottery is made to be used. These pots are fired to a higher temperature resulting in a more durable pot able to withstand the constant usage and transportation from one event to another. In addition the inside will have a clear glaze to make the vessel more hygienic and user friendly.

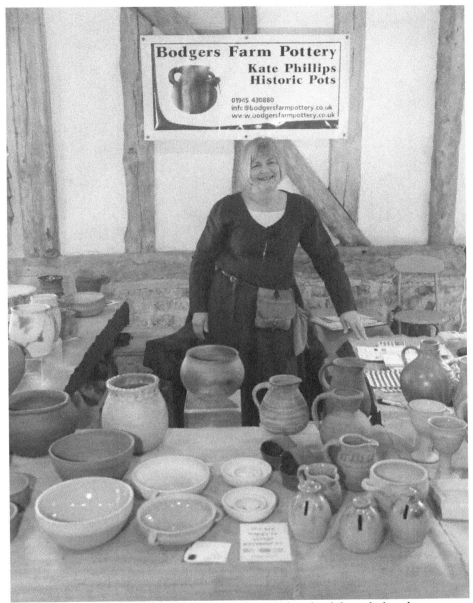

Fig. 5.1. The author, with a range of prehistoric and historic plain and glazed wares on display (© Kate Phillips 2017).

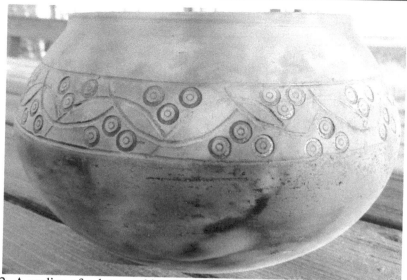

Fig. 5.2. A replica of a later prehistoric bowl. This was produced for *'Living History Teachers.'* The decoration and form appears very similar to an early Iron Age Le Tène globular bowl pottery form, technology dating to c.700-400 cal. BC: function food vessel and storage bowl (© Kate Phillips 2017).

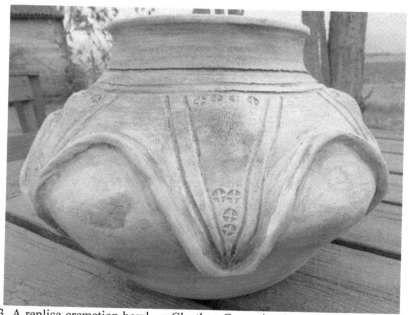

Fig. 5.3. A replica cremation bowl - a Cleathan Cremation Urn, Viking period. This urn was made for BBC children's programme, *'Wolf Blood'* (© Kate Phillips 2017).

Working in the niche market of making historic pottery is immensely satisfying. My work enables me to research history through the ages, learning from every new referral how ancient potters worked. Of course each pot had a specific function and this would have meant designing the pot to perform that function, however the individuality found in ancient pots is remarkable. The patterns on the surface of the clay, roulette markings, gouging, incising, stamp marks, additions, colour, texture and the clay body used all allow the pots to tell a historic story.

A Female Potter: a Reflection

There are a few drawbacks to being a woman potter - my hands are often rough and dry. I never have long pretty painted finger nails, in fact my nails are usually clogged with clay. I sometimes could do with more upper body strength to lift clay, especially if digging and preparing my own clay mixes. On the bright side my finger prints are smooth and shiny due to handling clay full of gritty inclusions. So, in theory I could rob a bank and not leave any identifying finger prints!

Appendix

A listing of Commissions include:

1. The British Museum, London: Copal Incense burners for the Mexican day of the dead

2. Norfolk Museums Trust: Ely ware, Viking ware through the ages, display pots and handling pots

3. Shakespeare Trust: Medieval money boxes

4. Department of Classics, Ancient History and Archaeology, The University of Birmingham: Bronze Age beakers

5. English Heritage, Totten Castle: Medieval pottery

6. Jorvik Viking Centre, York: Supply of multiple pots for the complete re-fit for exhibition and tourist attraction following flood damage

7. ARCHEAON Netherlands: Supply of fifty pots for a Neolithic village tourist attraction

8. CBBC TV filming for *'My Story'* children's programme at West Stow Anglo Saxon Village

9. Lynn Museum, Norfolk Museums Service: Video loop making Viking pots.

Chapter Six

Brewers, Bawds and Burgess Wives: the lives of women in medieval Lynn

Susan Maddock

Abstract

Our picture of medieval Lynn society has always been dominated by the activities of its merchant class of men, but new research is uncovering evidence of the contributions made by women to the town's economic and cultural life.

Margery Kempe is the best known urban businesswoman of her time, but Lynn's leet court rolls, 1309-1434, show that she was not alone: other Lynn burgesses' wives and widows ran brewing enterprises, as did brothel-keepers, and several of the town's resident aliens. Among women lower down the social scale, selling ale and foodstuffs was also a common means of earning a living. The leet court's efforts to deal with neighbourhood tensions show women as both victims and perpetrators of violence and anti-social behaviour, and expose changing attitudes to vocal women, who were increasingly likely to be characterised as 'scolds' from the mid-1420s onwards.

Introduction

And than, for pure coveytyse and for to maynten hir pride, sche gan to brewyn' and was on of the grettest brewers in the town' N. a iij yer' or iiij tyl sche lost mech' good for sche had neuer vre therto.

(Meech and Allen 1940, 9).

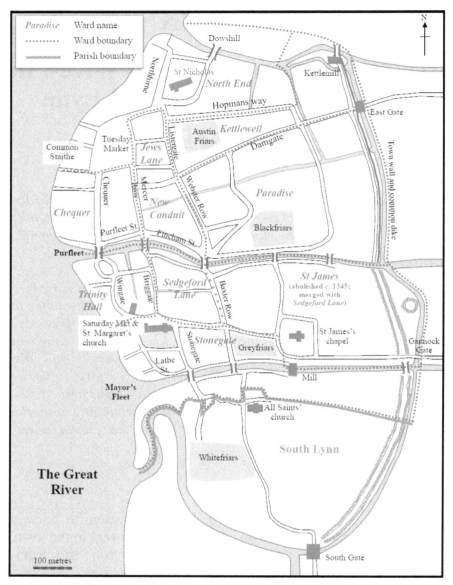

Figure 6.1. Map of Lynn in the late medieval period, showing the locations of the nine wards into which the borough was divided and its boundary with the separate parish of South Lynn (© Susan Maddock 2017).

These words come from medieval Lynn's best-known female brewer, Margery Kempe. Motivated by her desire to impress and to cut a stylish

figure among her neighbours, she began brewing for profit, and was one of the greatest brewers in the town for three or four years. After this initial success, and despite having good servants and a sound knowledge of brewing, she somehow lost the knack, the fermentation process repeatedly failed, and, as a result, the enterprise collapsed. Unlike the second industry at which Margery Kempe tried her luck - grinding corn with a horse mill - the brewing and selling of ale in medieval Lynn is well documented, thanks to the close regulation of trade in this staple commodity and also to the survival of records of the borough's annual leet court (Borough of Lynn 1309-1434; Borough of Lynn 1349 and 1400). Presentments relating to the brewing and selling of ale are among the most numerous in Lynn's leet rolls, as they are in the equivalent records of medieval manors and boroughs across the country.

Medieval Brewing, Women and the Leet Court

Judith Bennett (1996), in an authoritative study of brewing in medieval and early modern England, found that brewing around 1300 was an extension of domestic production; a small-scale, local industry, dominated by women. In Lynn, in 1309 - the year of the first surviving leet court roll - 127 women and 18 men were presented and amerced (required to pay a financial penalty) for brewing and selling ale against the assize. The overwhelming majority of the female brewers were married women, identified as 'wife of' a named man: just 20 were single women. 62 of the husbands of the married brewers are also named in a tallage roll, 1306 (the nearest to 1309 of the surviving assessments for tallage, a local tax levied on goods and money), which shows they were assessed at sums ranging from 5 pence to 40 shillings (the highest sum, levied on just three wealthy merchants in the town). Most of the remaining 45 married brewers' husbands had presumably been too poor to come within the scope of the assessment (Borough of Lynn 1306). As Bennett found elsewhere in England, brewers in early fourteenth-century Lynn were typically married women, albeit from a wide range of social and economic circumstances (Bennett 1996, 27). Among 71 non-brewers selling ale in 1309, 59 were women, of whom 29 were married. The 30 unmarried women included five described as hucksters and another five who were lodgers in houses belonging to named men, such as Basile, living in the house of Peter de Folsham, constable of Lynn's

southernmost ward, Stonegate (Fig. 6.1). Peter's wife brewed and sold ale, so Basile may have been selling on ale from the household in which she lodged.

The picture in Lynn changed very rapidly after 1309, as the two line graphs, based on numbers of male and female brewers and ale-sellers in the 19 surviving complete leet court rolls, illustrate (Figs. 6.2 and 6.3).

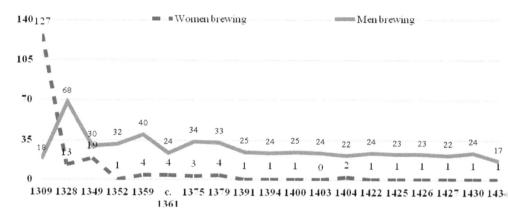

Figure 6.2. Line graph showing the numbers of male and female brewers recorded in Lynn leet rolls (complete years only), 1309-1434.

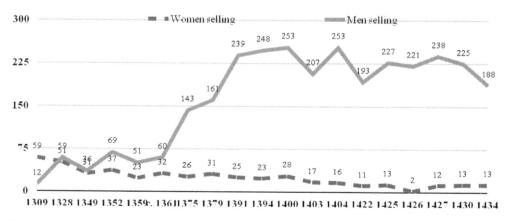

Figure 6.3. Line graph showing the numbers of male and female non-brewing sellers of ale and beer recorded in Lynn leet rolls (complete years only), 1309-1434.

The shift between 1309 and 1328, the year of the next complete leet record, is so startling (the number of women presented as brewers dropped from 127 to 13, only one of whom is identified as married, while the number of men brewing rose from 18 to 68), that we need to consider whether it reflects a change in recording, rather than in reality. Perhaps the men of the household were being held responsible in 1328, even if it was mainly women who were still in charge in practice? Alternatively, the 1309 record, which is unlike any other surviving leet roll in not being arranged by ward, might be unusual in ascribing responsibility to women for joint enterprises by husbands and wives. There are two reasons for rejecting these possibilities. One is that married, as well as unmarried, women continued to be presented to the court over the next hundred years for violent or antisocial behaviour, for leaving refuse on, or obstructing, the streets and waterways, for trading offences relating to the sale of food and ale, and, occasionally, for brewing against the assize, so there were no legal or procedural obstacles to their being held to account by the court. The other reason for accepting that a transition from women to men being the main brewers between 1309 and 1328 is a real one, is that 26 of the 107 married women amerced as brewers in 1309 also appear as brewers in a collector's account of revenue from the leet court, 1311 (Bailiff of the bishop of Norwich at Lynn 1311). This roll of extracts, heavily annotated by the bailiff of the bishop of Norwich, who was responsible for collecting the amercements, is untidy and sometimes unclear, but has enough continuity with the leet record of 1309 to show that the latter is not a capricious exception in holding wives responsible for brewing enterprises. However, 44 of the brewing wives and 14 unmarried female brewers from 1309 are not named at all in the 1311 account: a few, at least, must have died and others may never have been regular brewers for sale.

By 1328, a generation after the first leet record for the borough, the number of brewers overall had plummeted from 145 to 81 and the gender balance had flipped (Figs. 6.2 and 6.3): men now outnumbered women by five to one. Of 13 female brewers in 1328, only one is identified as being married. Among ale-sellers who were not brewers, the number of women was roughly stable (59 in 1309; 51 in 1328), but the number of men selling ale had increased almost fivefold, from 12 to 59. Already, men had

begun to dominate the business of supplying ale in Lynn, some twenty one years before the Black Death. This is the point that Bennett (1996, 43) identified as a watershed in the transformation of brewing from a home-based, low-profit sideline mainly carried out by women, into a brewhouse-based, high-profit, occupation dominated by men. Jacques Beauroy (2011), in a study of women's commercial and other activities at Heacham, a Norfolk market town only fourteen miles from Lynn, also found no evidence of decline in women's dominance as brewers in a series of leet court rolls ending in 1324. Moreover, at Ramsey, a market town in Huntingdonshire, less than forty miles from Lynn, women continued to dominate the brewing trade in the second half of the fourteenth century, albeit in smaller numbers overall (DeWindt and DeWindt 2006, 236). The much earlier, and more dramatic, change at Lynn therefore appears to be well ahead of developments elsewhere. A possible explanation for the early and rapid commercialisation of brewing in Lynn is that it was driven initially by wealthy merchants who had the capital to invest in new equipment and labour, and their enterprises were only gradually overtaken by specialist, or professional, brewers.

Before and after the Black Death
The word 'wife' occurs only once in the 1349 roll (not in relation to brewing) and the record of that year's leet court is exceptionally succinct and businesslike. The court met in late October, as it did every year, but in 1349 it followed a devastating summer, during which the Black Death swept through the town. Many of those who would normally have been presented had died, and most of those who survived had been bereaved: in the circumstances, any mention of family relationships was best avoided.

The story of the Swerdeston family exemplifies both changes in brewing and the impact of the Black Death. Alan de Swerdeston was one of the wealthiest burgesses of Lynn in the early fourteenth century. He owned three tenements on the north side of the Tuesday Market. Two were adjacent to one another and near (but not immediately adjoining) the corner of what is now Page Stair Lane; the third was next door but one to the east. Between his two easternmost tenements was one belonging to another wealthy burgess, Robert Betele. This run of properties along the north side of Tuesday Market is not referred to in the Newland survey of

*c.*1279, but was probably first developed very soon after, since a house in that area is described in a deed of 1288 (Owen 1984, 155). Alan de Swerdeston's wife, Tiffany, was brewing for the market in 1309 and 1311, when her amercement was 5s., the highest level imposed on brewers that year. She was widowed between then and August 1316. Substantial extracts from the couple's testaments, copied into the town's Red Register (Ingleby 1919-22, vol. 1, 74-5) show that Alan and Tiffany had three sons, John, Richard and William, each of whom was to have one of the three Tuesday Market tenements. Tiffany also had an older son, Thomas, by a previous marriage, but known by his step-father's name, as Thomas de Swerdeston. By 1328, it was Tiffany's oldest sons, John and Thomas de Swerdeston, who were the family's brewers.

John de Swerdeston (Alan's oldest son) and his wife Muriel brought up two sons, John and Nicholas, and a daughter, Margery, who married her father's neighbour and business partner, Hugh, son of Robert de Betele. Hugh died in January 1349, and in June, at the height of the pestilence, Margery, her father and her brother-in-law, Henry de Betele, all died within days of one another (Ingleby 1919-22, vol. 1, 182-8 and 191-3). Margery's mother, Muriel, meanwhile, carried on brewing, at least for a while, and Muriel's daughter-in-law, Katherine de Swerdeston, similarly continued brewing after the death of her husband, Thomas. This pattern, of widows continuing brewing enterprises after the death of their husbands, recurs in the decades after the Black Death, and was the most common exception to men, rather than women, being the main brewers in Lynn from the 1320s onwards.

The leet roll of 1349 is the last in which women appear as brewers in significant numbers: there were 19, compared with 30 men. Thereafter, the number of female brewers collapsed, while the number of men brewing settled into the low twenties by the late fourteenth century (Fig. 6.2). Many more women must have been engaged in brewing as employees, but household servants are rarely visible in the archival record, except in the incomplete poll tax return for Lynn, 1379. Fortunately, that year's leet roll also survives, enabling the households of some of the brewers to be identified in the poll tax. John de Dunham, a merchant-burgess living in New Conduit ward (Fig. 5.1), was the largest

brewer in Lynn in 1379, brewing 36 quarters of malt a week (far more than John Kepe, whom Judith Bennett mistakenly identified as 'the greatest of Lynn's brewers', from a published transcript of a small section of the leet record (Bennett 1996, 48; Owen 1984, 421) and paying an exceptionally high amercement of 70 shillings. From the poll tax return, we know that John de Dunham was married, and had six servants, five of whom were female, so at least some of them must have been carrying out work in the brewery, probably in combination with other household tasks (Fenwick 2001, 185).

Ale and Misdemeanours
Despite the high social standing of many brewers, the brewing and selling of ale could also be associated with antisocial behaviour, and it was overwhelmingly women whose misdemeanours as brewers and ale-sellers were caricatured in the art and literature of the fourteenth and fifteenth centuries, despite their being a diminishing proportion of those actually engaged in the trade (Bennett 1996, 122-44). The use of false measures was regarded with particular severity. In the *Holkham Bible Picture Book* of around 1330, for example, a naked woman, her offence signified by the flaming ale-jug in her left hand, rides piggy-back on a devil who is about to hurl her into a boiling cauldron. Perhaps the threat of damnation, or the social disapproval it embodied, really did deter ale-sellers from using fraudulent measures: in Lynn's surviving leet rolls, 1309-1434, only three women were amerced for using a false measure for ale. Two of these were presented in 1309; the third in 1400. By contrast, ten men were amerced for false ale measures, all between 1352 and 1400. Presentments of both men and women for using false measures were much more common for other commodities, including flour, oats, candles and wine. Failure to bring weights and measures, including those for ale, to the annual leet court for inspection was also a common reason for traders to be amerced.

The consumption of ale in hostelries and lodging houses might lead to drunkenness, and a disorderly house might be one frequented by prostitutes. In 1346, the court seems to have targeted people who harboured prostitutes or who let them live in properties they owned. Despite the leet rolls being incomplete that year (three whole wards are

missing) the number of presentments for this offence is exceptionally high. Of 11 men and seven women amerced, all but two of the men and all the women were in the borough's southernmost ward, Stonegate (Fig. 6.1). Prostitutes are identifiable in that area from 1328, when three men were presented for attacking an unnamed prostitute and it continued to attract attention as an area in which prostitutes operated until at least 1379. One woman's name appears more frequently than most in leet entries for Stonegate in the 1360s and 1370s: that of Matilda de Crosby, who first comes into view as an ale-seller in an undated leet record of *circa* 1360. In the same year, she was involved in two incidents which led to the hue - the medieval equivalent of dialling 999 - being raised: once by, and once against, her. Alice Scayle justly raised the hue against Matilda de Crosby for bloodshed (Matilda was amerced 12d. for the bloodshed and 6d. for the justified hue), while Matilda justly raised the hue against a saddler called Thomas de Ludham, who had attacked Matilda in her house (hamsoken) and drawn blood. He was amerced in the same sums as Matilda for the bloodshed and hue - 12d. and 6d. respectively - and another 3d. for hamsoken. In other words, the offences by and against Matilda were treated similarly, despite the difference in the gender of the perpetrator, and despite the nature of Matilda's other activities. She was amerced 40d. in the same year for keeping a hostelry which harboured thieves and prostitutes, and a year or so later (*circa* 1361), 3s. 4d. for keeping stews and prostitutes. She was still in business in 1379, when she was amerced 2s. for regrating ale (buying ale for resale at a higher price), keeping a brothel and not bringing her measures for inspection, but also a separate, and higher, sum of 3s. for selling ale without using an officially sealed measure, which puts the brothel into perspective. Brothels were less of a social problem in themselves; more for the occasionally inflammatory mix of people who frequented them.

Continental Immigrants and the Introduction of Beer

From the second decade of the fifteenth century, a change of tone is evident in leet entries relating to women who were prostitutes or who kept brothels, and their activities no longer appear to be concentrated in Stonegate ward. In 1416, for example, an ale-seller named Agnes, who lived in a house of Bartholomew Petypas in New Conduit ward (Fig. 6.1), was said to harbour prostitutes and German-speaking aliens (*duchemen*)

at night, so that men dared not walk past, nor come out of their own houses, while in Chequer ward in 1430, the wife of William Andrew, described as a prostitute, a bawd and an eavesdropper, kept a common brothel in which nocturnal affrays were a frequent occurrence. From 1427 onwards, a few women who kept brothels, and several more who did not, were also presented to the court as common scolds, reflecting a wider change in how women - inconveniently vocal women, at least - were perceived.

Although the reference to visiting *duchemen* in 1416 suggests that they were seen as a potential threat, Lynn also had a substantial resident population of Continental immigrants, who were known to their neighbours and subject to the jurisdiction of the leet court in the same way as the rest of the borough's inhabitants. Foreign-born women are less easy to identify than men, but three *duchewomen* are clearly identified as such in the early fifteenth-century leet rolls, and they were all presented for selling beer (not ale) against the assize. They are Gysburgh (New Conduit ward, 1403) Helwisa (Trinity Hall 1400), and Katerina (Trinity Hall 1404) (Fig. 6.1). Beer, brewed on the Continent with hops, in addition to malt, water and yeast, was still a relatively new taste in England at this time. Sales of imported beer are first recorded in London in the early 1370s (Bennett 1996, 79-80), and immigrants were among Lynn's beer-sellers in the 1370s: the first alien recorded in surviving leet rolls as selling beer is Ethelbert Osterling in 1375. He was by no means the first beer-seller in Lynn, however: seven men were selling beer in Lynn in 1359, more than a decade before the earliest record for London. The brewing of beer in England seems not to have begun before 1400 (Bennett 1996, 80), and there is no evidence that beer was yet being brewed in Lynn in the earliest years of the fifteenth century, but a handful of 'beerbrewers', including Joan Beerbrewer, *duchewoman*, begin to appear in the leet records from 1416 onwards and records of national taxes on aliens name six foreign beer-brewers (one based in South Lynn) living at Lynn in 1449-50 (York 2012-15). One of the seven men who were selling imported beer at Lynn in 1359 was Margery Kempe's future father-in-law, John Kempe, so we should not be surprised to find that John Kempe junior and his wife Margery chose beer as their picnic tipple in 1413:

It befel upon a fryday on Mydsomyr evyn' in rygth' hot wedyr', as this creatur was komyng fro Yorke ward beryng a botel wyth bere in hir hand and hir husbond a cake in hys bosom

(Meech and Allen 1940, 23).

The Kempes' Brewery

Both John Kempes and Margery were engaged in brewing for varying periods of time (John Kempe senior was among the five biggest in 1379, brewing 30 quarters of malt a week), but of English ale rather than continental beer, and as a sideline, rather than their main source of income. As we have already seen, the profile of brewers in Lynn had already changed dramatically in the first quarter of the fourteenth century.

After the Black Death, per capita consumption of ale rose creating a larger market and opportunities for entrepreneurial brewers to invest in equipment with a view to making a living, rather than merely supplementing household income (Bennett 1996, 43-4). This transition, unlike the shift from mainly female to mainly male brewers, was a gradual one, and was in progress in Lynn throughout Margery Kempe's lifetime (*c*.1373-*c*.1440). One of the first editors of her book, Sanford Meech (Meech and Allen 1940), searched those leet records which had at that stage been identified as covering the period of Margery's life, and found the only two references to brewing by John Kempe, Margery's husband, in 1403 and 1404. He speculated that these might relate only nominally to John, and actually reflect his wife's activities (Meech and Allen 1940, 364). Some perspective on John Kempe's brewing business can be obtained by looking at all 48 leet amercements for brewing in 1403 and 1404, 24 in each year. In all, 29 individuals were presented (nine of them named in only one or other of the two years; the remaining 20 in both): of these 29, two were women, which suggests that had Margery Kempe's brewery been active in those years, she would have been named. The amercements ranged from 13d. to 46s. 8d., the highest sums being due from prominent burgesses who were also wealthy merchants, such as Robert Salesbury, who lived in Lathe Street, in a house (now Hampton Court) and brewery acquired through his marriage to the widow of Robert atte Lathe (Salesbury 1429).

John Kempe was one of four men amerced in New Conduit ward for brewing in 1403 (13s. for six quarters of malt a week), and one of five in 1404 (5s. for two quarters). He was brewing quantities below the average, which suggests that his brewing was a sideline which was ticking over satisfactorily, but no more. The ambitious Margery, impatient at her husband's laid-back approach to business, may have taken over the running of the modest Kempe brewery and scaled it up, in emulation of the most successful merchant-brewers. There is no reason to doubt Margery's boast that she was one of the biggest brewers in the town for three or four years: a generation earlier, in 1374, Cecily de Couteshale, widow of John de Couteshale (a prominent merchant who served five times as mayor between 1349 and 1366), had been the biggest brewer in the borough. Margery's father, John de Brunham, was part of the same ruling élite as John de Couteshale for at least a decade, so the two families would have been well known to one another.

Although only a handful of women had brewing enterprises by the early fifteenth century, compared with 127 in 1309, Avice Fraunke, a North Ender, was brewing eight quarters a week in 1404, while Katherine Silesden, the widow of John Silesden, burgess, was responsible from at least 1425 to 1430 for a modest (between three and six quarters a week) brewery in Stonegate ward. This had previously been managed by her husband, and before that by his father, William Silesden. The Silesdens were of similar status to John Kempe junior: merchant-burgesses, but not particularly wealthy or prominent in public life. In 1384-5, for example, William Silesden served one term as one of the borough's four chamberlains, as did John Kempe a decade later.

Margery Kempe's link with the new commercial Brewers
Margery Kempe's own name appears only twice in surviving records of her home town: the Trinity gild accounts include the two final instalments (20s. each, paid during Lent 1438 and 1439) of her £5 admission fee to the gild (Meech and Allen 1940, 358). On both occasions, the money was handed over by John Ashenden, who, with his long-term business partner, Edward Mayn, owned the biggest brewery in Lynn in the 1430s. Ashenden and Mayn, who were based in Trinity Hall ward, were prominent among a group of 'artificer burgesses' who, in the 1420s,

successfully pressed for equality with the merchant-burgesses who had previously exercised exclusive rights and privileges within the borough hierarchy (Borough of Lynn 1422-9, 29-33). Both men served one term as chamberlain (Ashenden in 1420-1; Mayn in 1424-5), and in 1440 John Ashenden became mayor, an achievement which would have been unthinkable a generation earlier for a burgess who was not also a merchant.

In the same year that Margery Kempe paid the penultimate instalment of her entry fee to the Trinity Gild, John Ashenden's wife, Isabel, together with Edward Mayn's wife, Joan, were also admitted: their names were entered together in the gild accounts, just as their husbands' names were almost invariably, paired in a business context (Trinity Gild 1437-8). It seems likely that Margery was friendly with Isabel and Joan, and the three women's decisions to become Gild members may even have been a joint one. Margery Kempe's book is notoriously silent about the political and social conflicts of her home town in the early fifteenth century, and equally so about the lives, or deaths, of all but one of her children. But, it is just possible that Isabel Ashenden was her daughter, and certain that Margery, at the end of her life, had formed a social connection with members of a newly empowered class within the borough of Lynn.

Documentary Sources

Bailiff of the bishop of Norwich at Lynn, 1311. Leet revenue account roll. Norwich Cathedral Archives. DCN 44/76/176. Norwich: Norfolk Record Office.

Borough of Lynn, 1306. Tallage roll. King's Lynn Borough Archives. KL/C 37/5. King's Lynn: King's Lynn Borough Archives.

Borough of Lynn, 1309-1434. Leet rolls. King's Lynn Borough Archives. KL/C 17/1-22. King's Lynn: King's Lynn Borough Archives.

Borough of Lynn, 1349 and 1400. Leet rolls. Arundel Castle Manuscripts. MD 1475 and MD 1478. Arundel: the Duke of Norfolk's archives.

Borough of Lynn, 1422-9. Hall book. King's Lynn Borough Archives. KL/C 7/2. King's Lynn: King's Lynn Borough Archives.

Salisbury, R., 1429. Will. King's Lynn Borough Archives. KL/C 12/11. King's Lynn: King's Lynn Borough Archives.

Trinity Gild, 1437-8. Account. King's Lynn Borough Archives. KL/C 38/16. King's Lynn: King's Lynn Borough Archives.

References

Beauroy, J. 2011. *The social rôles and status of women in a Norfolk small market town: Heacham 1276-1327.* Cambridge Group for the History of Population and Social Structure conference paper. Available at:
www.campop.geog.cam.ac.uk/events/richardsmithconference/papers/Beauroy.pd
[Accessed 15/08/17].

Bennett, J. M. 1996. *Ale, Beer, and Brewsters in England: Women's Work in a Changing World, 1300-1600.* Oxford: Oxford University Press.

DeWindt, A. R. and DeWindt, E. B. 2006. *Ramsey: the lives of an English Fenland town, 1200-1600.* Washington DC: The Catholic University of America Press.

Fenwick, C. C. 2001. *The Poll Taxes of 1377, 1379 and 1381 part 2 Lincolnshire-Westmorland.* Oxford: Oxford University Press for the British Academy.

Ingleby, H. (ed.), 1919-22. *The Red Register of King's Lynn.* King's Lynn: Thew and Son (2 volumes).

Meech, S. B. and Allen H. E. (eds.), 1940. *The Book of Margery Kempe.* London: Oxford University Press for the Early English Text Society.

Owen, D. M. 1984. *The Making of King's Lynn: A Documentary Survey of Lynn.* Oxford: Oxford University Press for the British Academy (Records of Social and Economic History, new series 9).

York, University of, and The National Archives, 2012-15. *England's Immigrants 1330-1550.* Available at: https://www.englandsimmigrants.com [Accessed 19 Apr 2017]).

Chapter Seven

Charlotte Atkyns

The Female Scarlet Pimpernel

Lindsey Bavin

Abstract

Spy or eccentric - the enigmatic character of Charlotte Atkyns *née* Walpole is something of a mystery (Fig. 7.1). A brief overview is given here of her life and times and how she finally met her end. Was she Norfolk's *Mata Hari* or simply an actress with delusions of grandeur? Where did the nickname the female Scarlet Pimpernel come from and why does she deserve to be included with these other illustrious women?

Introduction: Charlotte Atkyns *née* Walpole

My story begins a long way from Norfolk. Charlotte Walpole was born in 1757 in County Westmeath in Ireland. There is limited information on her origins other than what her father shared the same name as King's Lynn's famous son and First Prime Minster, Robert Walpole and is thought to be a distant relative of him, though the legitimacy of that claim would be incredibly hard to prove.

Charlotte's aspiration was to be an actress and her ambition was achieved in 1777 when she made her stage debut in London at the Crow Street Theatre playing Leonora in Isaac Bickerstaff's *The Padlock*. It did not take long before Charlotte had made her way up the ladder to play the Drury Lane Theatre in October of the same year.

By this point a beauty of some renown, according to Walton (2017) Charlotte was described as 'having the face of an angel' and being 'pretty, witty, impressionable and good'. It was at the Drury Lane Theatre where

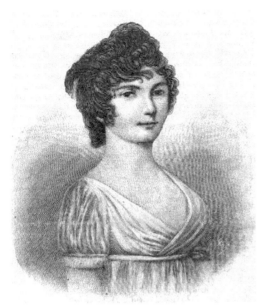

Figure 7.1 Charlotte Atkyns (After Walton 2017)

she attracted the attention of nobleman, Sir Edward Atkyns Esq. As the grandson of the Chief Lord Justice and heir to Ketteringham Hall in Norfolk their match was viewed poorly by the local elite. Nevertheless, Edward married Charlotte in 1779 and they had two sons, Edward and Wright Edward by 1780.

Rather than legitimising the relationship the gentry rejected Charlotte entirely as is shown in a letter by Lady Jerningham written in 1784,

'Mrs Atkins [sic] of Ketteringham. She was a player, a friend of Miss Younger. You may remember to have heard of her and he was always a great simpleton or else he would not have married her.'

(Chandler 2016, 8).

The French Revolution
By November 1784 the pair decided to abandon England and its gossips in favour of Lille and the dazzling court of Versailles.

According to Chandler (2016) Charlotte Atkyns was introduced to Marie Antoinette by Yolande Martine Gabrielle de Polastron, Duchess of Polignac. Having been a fish out of water herself, it came as no surprise that Marie Antoinette would look fondly on the pretty actress who had married well above her station.

They would have a few years of relative peace before the start of the French Revolution in 1789. Charlotte and Edward returned frequently to Ketteringham Hall and much like her fictional namesake the Scarlet

Pimpernel used her connections to help French émigrés fleeing the guillotine such as journalist and founder of the newspaper *The Acts of the Apostles* Jean-Gabriel Peltier (Fig. 7.2).

Figure 7.2. Jean Gabriel Peltier, 1760-1825 (After Wikipedia 2017a).

Charlotte would use the money she had married into to hire couriers to carry secret messages across the North Sea, bribe officials and charter ships to linger around the coast for months at a time as there was no knowing just how many would need to flee.

It was in 1791 that Charlotte was recruited by Louis de Frotté (Fig. 7.3) as a spy for the counter revolutionary royalist forces. The regard revealed in the letters between them indicates that their relationship may have gone beyond spy and spymaster.

> 'O exquisite woman, let our Revolution end as it may, and even if you should have no part in it, you will still and forever be to me the tender and devoted friend of Antoinette and she to whom I hope someday to owe all my happiness.'
>
> Letter to Charlotte Atkyns from Louis de Frotté, 1793 (in Anon 1906, 235).

Although little is recorded of her clandestine activities, her main focus appears to have been the rescue of Marie Antoinette. Charlotte planned to use her talents acquired upon the stage to make it to the Queen.

Figure 7.3. Louis de Frotté, 1766-1800 (After Wikipedia 2017a).

Marie Antoinette and the Dauphin Louis Charles

One story is of a daring attempt to rescue Marie Antoinette from prison by Charlotte disguising herself as a member of the National Guard (Barbey 1879). There were numerous factors against her. She planned to travel alone, her French was limited and she was strongly warned against the attempt by her friend, Jean-Gabriel Peltier wrote to her saying;

'If you leave your hotel three times in the day, or if see the same person thrice you will become a suspect.'

The aim was that Charlotte would gain entrance to the Conciergerie where Marie Antoinette was being held. Swap clothes with the Queen and take her place. Several unsuccessful attempts had already been made to free Marie Antoinette, one shortly before Charlotte's attempt which resulted in the arrest of the royalist sympathisers. Once more Peltier tried to dissuade her from making the attempt.

> 'If you wish to be useful to that family you can only do so by directing operations from here (instead of going there to be guillotined), and by making those sacrifices you have already resolved to make.'

Peltier failed to deter Charlotte and she made her first attempt to reach the Queen. Her disguise worked but the note she intended to pass to the Queen fell out at an inopportune moment. A guard noticed but Charlotte swallowed the note before it could be read but her suspicious behaviour meant she was ejected.

Her second attempt was to appeal to the captors wallets (Barbey 1879). Charlotte paid a fortune in bribes to spend just one hour in the Queen's company. This was successful and she reached Marie Antoinette on 2nd August 1793. However the plan failed because despite pleading from Charlotte the Queen refused to leave her children or let Charlotte sacrifice her life for her. It was the Queen's last opportunity to escape as the earlier failed escapes had meant security had been tightened. Marie Antoinette is said to have requested Charlotte turn her efforts to save her 8 year old son, the Dauphin Louis Charles. Marie Antoinette was executed on 16th October 1793.

Charlotte's husband Edward passed away on the 27th March 1794 leaving his estate to Charlotte. Now an independent and still reasonably wealthy woman Charlotte threw herself into a variety of political causes both in Norfolk and France.

Her main focus was fulfilling her promise to save Marie Antoinette's children, specifically the Dauphin. Charlotte was involved in a plot with Madame de Beauharnais and her spymaster Louis de Frotté to replace the Dauphin with a lookalike. Unfortunately they were not the only one to have this idea and there were for a time several 'Dauphins' at the Temple and there would be many who would later claim to be the Dauphin. One child was smuggled out into Charlotte's care but it turned out to be a false Dauphin. Another 'Dauphin' escaped the Temple in 1794 but Charlotte had no idea as to his whereabouts or if it was the real Dauphin. She visited the false Dauphin, Mathurin Bruneau who had been imprisoned and spent some of her dwindling resources towards the end of her life in 1821 trying to free him. Charlotte also visited another imprisoned false Dauphin in 1834, Henri Hebert, the Baron de Richemont.

The fate of the real Dauphin is still a mystery to this day. Charles Louis was reported to have died of tuberculosis aged only ten years but Charlotte refused to believe this which led to a cooling of her friendship with Louis de Frotté and an end to her days in espionage.

Prince Regent's Grande Fete

Despite this she continued to help French émigrés and strove to find the Dauphin. To fund her cause she mortgaged Ketteringham Hall in 1799.

Charlotte Atkyns would have one last major public appearance as the Lady of Ketteringham Hall. On 19th June 1811 Charlotte was one of two thousand invited to attend the Prince Regent's Grande Fete. It was intended to honour King George III's Birthday and to show support for the exiled royalty of France. The true subject of the fete was the ascendancy of the Prince Regent to the throne, voted in by parliament due to his father's failing mental health. The lavish event held at Carlton House is thought to have cost £15,000, though the poet Shelley said the entertainment alone must have cost £120,000 (Bieri 2004, 168). The streets were blocked with carriages of not only the attendees but those who wished to marvel at the extravagant spectacle. That Charlotte was invited was a huge honour and testament to her role during the revolution.

After Louis XVIII was restored to the throne in 1814, Charlotte petitioned for her expenditure to be covered by the French government which had approached £40,000. Her aid had come at a hefty price, equivalent of c.£15 million today. It was denied.

By 1824 Charlotte reached the limits of her fortune and had no choice but to sign over Ketteringham Hall to her sister-in-law Mary Atkyn. She returned to Paris where she would end her days a pauper accompanied only by her loyal German maid Victoire Ile. Charlotte's tales of adventure were thought by many, simply the eccentric ramblings of an old English woman. The letters detailing her involvement were viewed as a fabrication.

We know from Charlotte's will, that her last wish was to be interred in the family vault in Ketteringham Hall and for her name and age to be inscribed next to the monument of her son Edward. Edward died aged thirty six in the same year she lost her husband.

Charlotte Atkyns, the female Scarlett Pimpernel was buried in an unmarked grave in Paris and was largely forgotten until 1889 where she received a brief mention in John Goldworth Alger's, *Englishmen in the French Revolution* (1889, 125-6). There was a brief resurgence in interest

when the French playwright, Victoire Sardou, produced a comedic play based on Charlotte's life. Performed at the Vaudeville in Paris in 1896 it was called *Pamela, Merchande de Frivoltiés*.

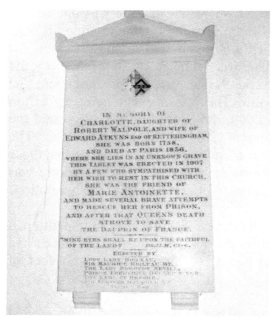

Figure 7.4. Memorial to Charlotte Atkyns in Ketteringham church (After Knott 2006).

A monument was erected to Charlotte Atkyns in Kettingham Church in 1907 by those who wished to fulfil in part Charlotte's last wish (Fig. 7.4).

Conclusions

Why does Charlotte Atkyns deserve to be included amongst philanthropists like Audrey Muriel Stratford or Edith Cavell? Both her goals to save Marie Antoinette and the Dauphin failed. She spent her entire fortune and ended her days a pauper in an unmarked grave.

One of the main reasons I believe that Charlotte Atkyns deserves to be counted amongst these brave and talented women is because she was both those things.

You can put aside the argument of the veracity of her story (Anon 1906). But, there is evidence that Charlotte Atkyns was talented by how quickly she rose from an Irish immigrant background, to a Drury Lane actress. Her bravery is proven by her decision to leave behind her country to start a new life and having to do it all again after her ill-matched marriage was the subject of scorn.

If her story is to be believed, then she took up a dangerous career in espionage. She also opened her home to aristocratic refugees despite having been rejected by the English aristocracy because of her low birth.

Furthermore, Charlotte was willing to give up her freedom and even her life for a Queen, who she considered a friend. Indeed, Alger retelling the story, added weight to its credibility,

> '...it seems clear that Mrs. Atkyns really endeavoured to effect Marie Antoinette's escape'.

(Alger 1889, 126).

A definition of a philanthropist is, 'the desire to promote the welfare of others, expressed especially by the generous donation of money to good causes' (Burton 2016). Even if her story regarding her daring escapades in France were embellished, Charlotte Atkyns was a 'philanthropist'. Her entire fortune was spent on protecting émigrés from the *Terror* of the French Revolution and trying to save the Dauphin.

As to her failure, well in 2017 the company Proctor and Gamble (2017) produced the advertising campaign #LikeAGirl which dealt with the paralysing fear of failure many women face. So, perceived failure is nothing new.

To discount someone's achievements from history because they did not achieve a specific aim would mean our museums and libraries would become very empty indeed.

So I will finish this chapter with the key statement of that, #LikeAGirl campaign,

> 'Failures aren't setbacks, failure is fuel. To keep going. To keep growing. To keep making progress. Try. Fail. Learn. Keep going. So let's keep failing because we only truly fail if we don't even try'.

(Deighton 2017).

References
Alger, J. G. 1889. *Englishmen in the French Revolution*. London: Sampson Low Marston, Searle & Rivington.

Anon. 1906. 'The Atkyns Romance'. Book Review of 'A Friend of Marie Antoinette (Lady Atkyns).' Translated from the French of Frédéric Barbey, with a Preface by Victorien Sardou of the French Academy, London. *The Spectator*, 18th August 1906, 235-236. Available at: http://archive.spectator.co.uk/article/18th-august-1906/20/the-atkyns-romance [Accessed on 29/10/17].

Barbey, F. 1879. *A Friend of Marie Antoinette (Lady Atkyns)*. London: S. Chapman and Hall.

Bieri, J. 2004. *Percy Bysshe Shelley: A Biography: Youth's Extinguished Fire, 1792-1816*. Newark: University of Delaware Press.

Burton, D. 2016. '*How to Make a Difference as an Everyday Philanthropist*'. 8th February 2016. Available at: https://www.linkedin.com/pulse/how-make-difference-everyday-philanthropist-dena-burton/?articleId=6102341576271355904 [Accessed on 29/10/17].

Chandler, M. 2016. *Historical Women of Norfolk*. Norwich: Amberley.

Deighton, K. 2017. *'Always' #LikeAGirl is back, and this time it's tackling girls' 'paralysing' fear of failure'*. The Drum, News, 17th August 2017. Available at: http://www.thedrum.com/news/2017/08/17/always-likeagirl-back-and-time-its-tackling-girls-paralysing-fear-failure [Accessed on 29/10/17].

Knott, S. 2006. *The Norfolk Churches Site: St Peter, Ketteringham*. January 2006. Available at: http://www.norfolkchurches.co.uk/ketteringham/ketteringham.htm [Accessed on 29/10/17].

Proctor and Gamble 2017. *'Always Epic Battle #LikeAGirl'*. 17th August 2017. Available at: http://www.pgnewsroom.co.uk/blog/citizenship-en/always-epic-battle-likeagirl [Accessed on 29/10/17].

Walton, G. 2017. *'Lady Atkyns's Plot to Save Marie Antoinette'*. Geri Walton's Unique Histories of the 18th and 19th Centuries. 30th June 2017. Available at:
https://www.geriwalton.com/lady-atkynss-plot-to-save-marie-antoinette/
[Accessed on 29/10/17].

Wikipedia 2017a. *Jean Gabriel Peltier*. Available at:
https://fr.wikipedia.org/wiki/Jean-Gabriel_Peltier#/media/File:Jean-Gabriel_Peltier.jpg [Accessed on 29/10/17].

Wikipedia 2017b. *Louis de Frotté*. Available at:
https://en.wikipedia.org/wiki/Louis_de_Frott%C3%A9#/media/File:Louis_de_Frott%C3%A9.jpg [Accessed on 29/10/17].

Chapter Eight

Audrey Muriel Stratford: a Twentieth Century King's Lynn Woman

Gill Bond and Elizabeth Pye

Abstract

This chapter focuses on the life and activities of Audrey Muriel Stratford (1907-2000) who lived in King's Lynn for most of her life. It outlines her interests in women's welfare, her involvement in her father's firm - Stratfords - which she inherited and managed, her research into King's Lynn local history particularly of buildings, and her interest in local issues such as improvements to housing. It introduces the books she wrote on committee work and on knitting. It concludes with a brief overview of the aims of the Audrey Muriel Stratford Charitable Trust, and the collection of her papers which forms an archive available for consultation in the King's Lynn Borough Archives.

Introduction

Audrey Stratford (1907-2000) was a King's Lynn woman, well-known in her life-time, who managed Stratford's clothing store and was involved in local issues. Her contribution to Lynn life and society deserves to be remembered (see Appendix).

Born in 1907 in South Africa, she was four when the family returned to the UK, initially to Norwich. In 1914 her father was sent to Lynn as a recruitment officer, and this began for Audrey a life-long attachment to Lynn. After university and a short career teaching physiology she returned to Lynn in the 1950s to manage her father's business. She campaigned locally on town planning and transport issues and committed her time to supporting the rights of women and girls through her membership of Soroptimist International and related bodies. She published books on knitting and business. She left a legacy in the form of the Audrey Muriel Stratford Charitable Trust, which supports the recording and reporting of local Lynn history, and she left a personal

archive consisting of memoirs, papers, publications and personal effects, which can now be consulted in the King's Lynn Borough Archives (Fuller 2011; Last 2007).

In accordance with the aims of this volume this paper presents an overview of her life, character and interests, and her voice as a 20th century woman. It is based largely on a preliminary exploration of her archive and focuses particularly on her interest in women's welfare and her contribution to the history of King's Lynn.

Her Voice

Her life spanned the 20th century; she not only experienced some of the enormous changes which have shaped the modern age, the innovations which we now take for granted such as cars and computers, and the growing independence of women, but commented on them in her memoirs. Although she died only 17 years ago hers is a voice from an earlier age - now almost another world. It is the voice of an intelligent, energetic, determined, independent-minded, practical woman (Fig. 8.1).

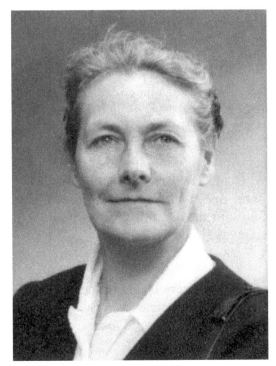

Her archive reveals her wide-ranging interests, particularly in local history (especially the various properties that her family had owned), the history of her own family and her father's firm, the welfare of women, health issues such as fluoridation of the water supply. Many of her own typed notes record charming memories, and indicate that she had a dry sense of humour. Audrey was fascinated by new technologies

Figure 8.1. Audrey Stratford in 1958 (Courtesy of the Trustees of the Audrey Muriel Stratford Charitable Trust).

and keen to adopt them, learning to drive a car as soon as she was old enough to do so legally, and obtaining a personal computer (an Amstrad) before many other people. (Amstrad plc, computers were amongst the first personal or home computers, produced between 1984 and 1990).

Her experience with motoring provides a good example of the changes she experienced in her life-time and also reveals much about her character. She describes a family trip to London in the early 1920s which involved five burst tyres. After using the spare tyre there was no alternative for the driver but to find the problem and patch it (there were few, if any, garages to help with repairs). She comments that she was taken out of earshot while the driver dealt with the damaged tyre!
Referring to her own experience of driving she says:

> 'I walked [to Taylor's Garage] after school on my birthday [presumably her seventeenth birthday in 1924] and not long after, having had a short run through of which pedal did what, I drove out into Norfolk Street [...] For an hour round about the area and from then, onward, on occasion and sometimes for the whole of a college vacation, [...] I did the driving for the firm'.

> (Stratford n.d [a]).

However after the war she gave up her licence as she considered that the car had become 'a dangerous, antisocial, costly toy which I refused to encourage and I did not renew my licence' (Stratford n.d [a]).

Her experience of learning to use her Amstrad computer also comes over clearly in her memoirs, for example at the end of typed notes about her intended Trust she inserts a horizontal line, then exclaims 'Eureka. I've been trying for months to find out how to draw a line' (Stratford 1993). This was in December 1993 when she was already 86!

A Twentieth Century Woman
She was born at a time when women's lives were changing and her own life exemplifies this. According to her undated notes on her own life, in 1919 she went to King's Lynn High School for Girls, and,

'as I had shown great interest in Science and as schools were then able to adapt to pupils' interests, a sufficient lab was established for me to take a chemistry School Certificate, the first from the high school'.

(Stratford n.d. [b]).

It is easy to imagine that her own determination and persistence may have played an important part in achieving the 'sufficient' lab. She went on to say:

'I went on to Bedford College, London, intending to continue with chemistry but changed and in 1930 graduated in Physiology'.

(Stratford n.d. [b]).

At the time this was a relatively unusual subject for a woman (Fig. 8.2).

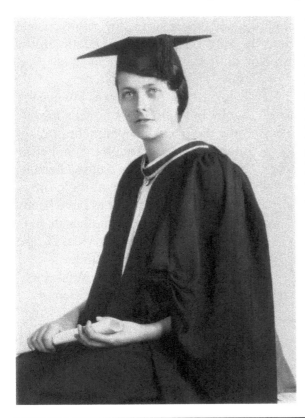

Until just after the Second World War she worked as a Lecturer in Physiology firstly at the Bergman Osterberg College of Physical Training in Dartford and subsequently at Chelsea College of Physical Education. She was an active member of the British Federation of Women Graduates and served as Honorary Secretary of the London Association of University Women at Crosby Hall,

Figure 8.2. Audrey Stratford on graduating in 1930 (Courtesy of the Trustees of the Audrey Muriel Stratford Charitable Trust).

1944-53. This link led to her being selected for 'a holiday Year of Rest and Recovery from Wartime Conditions' offered by the Western Australian Association of Women Graduates.

Her interest in the welfare of women and girls is illustrated in her active membership of the National Council of Women (in 1970 she attended the National Council of Women Jubilee Dinner at King's Lynn Town Hall, with the then President and Regional Chairman) and of Soroptimist International (see Appendix). She served for many years with the local King's Lynn Branch of the Soroptimists which was founded in 1975. Audrey was a founder member and was very active. There are several documents in her archive relating to the rights and welfare of women.

Stratfords and her Business Experience

In 1918 her father opened a shop on Norfolk street, selling army surplus stock which was the beginning of 'Stratfords' a well-known local business based originally in Norfolk Street, now Stratfords Limited, selling industrial protective clothing and located in the North Lynn Industrial Estate. Audrey inherited the firm on her parents' deaths in the 1950s and was its managing director until her own death in 2000 (Fig. 8.3).

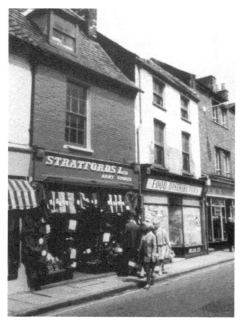

The base of the firm was always in Lynn, but during her father's lifetime there had been branches in other towns, (although it is not clear how many branches Audrey herself had). Based on information in the archives, there appear to have been shops at one time or another in Downham Market, Norwich, Long Sutton, Holbeach, Swaffham, Wymondham, Spalding, Wisbech, Ely, Boston, and possibly also

Figure 8.3. One of the early Stratford's shops, Norfolk Street (Courtesy of the Trustees of the Audrey Muriel Stratford Charitable Trust).

Brandon and Littleport. Accounts covering the management of Stratfords over a long period are included in the archive and could form the basis of an interesting study of the family firm, and provide insight into management and other issues affecting small independent businesses during the twentieth century.

Her Service on Local Committees

As well as being a member of the King's Lynn Soroptimists, Audrey was actively involved in many local committees including the King's Lynn Society of Arts and Sciences, the Civic Society, the Friends of King's Lynn Museum and the Borough of King's Lynn Housing Committee. She was also a member of national bodies such as the Business Archives Council and the Pure Water Association.

In the 1960's Audrey was a member of the Sites and Buildings sub-committee for Hillington Square (a large-scale council housing development in King's Lynn). Records show that she was particularly interested in central heating, the number of bedrooms, and safety issues in the new buildings.

By 1974 she was a member of St Margaret's Residents' Association through which she campaigned for local improvements, including generating a petition for a recreation area and fundraising to build a footbridge over the River Nar to ensure children walked to school safely. The committee minutes for 1979 indicate that better lighting at crossings, lorry bans, street cleaning and repairs, and changes to vehicle barriers to enable prams to pass by as some of the Association's campaign successes. After two years of negotiation, she gained permission for local children to use St Margaret's School's playing field as a play area over the summer, and for local residents and community associations to use the school premises for local activities.

Her experience of committee work led her to write a useful guide to committee organisation and procedure, under the slightly modified name of 'Audrie' Stratford (Stratford 1988). Aimed at anyone who wants to run a committee, no matter how big or small, it outlines the roles of committees, their purpose and how they function,

'I embarked on this book about amateur Committee work because I could not find any adequate printed guidance on the subject and also because I have a lengthening history of serving on and learning about committees. Being by nature a `joiner,' I have long revelled in at least a couple of dozen memberships at any one time. . .'

(Stratford 1988, 8).

The book still has a place today as it appears that there is nothing else on the market like it. Apart from committee procedure it also discusses how to run a campaign. It is worth noting that her campaigning activities were relatively novel at the time, but represent models of community engagement that are now popular across a wide range of resident and community groups throughout the country.

Her Interest in Local History: Life on Tuesday Market Place

She was interested in local history, the history and function of buildings and the changing townscape. Her childhood memories of living at number three Tuesday Market Place, where the family moved in 1919 while alterations were being made to the premises in Norfolk Street, are particularly vivid and say much about social conditions, and about Lynn at that time. Then, as now, the Market Place was full of banks, financial advisors and solicitors so did not offer easy daily domestic shopping for her mother (these were, of course, the days before fridges and freezers), so her father probably did some of the day-to-day shopping (unusual for a man at that time). However Audrey enjoyed the surroundings particularly the Common Staithe Quay, 'with all its many shaped buoys and piles of chain'. From her upstairs room she could observe activities in the Market Place:

'...looking down on the lights and movement when the Mart was there and being able to enjoy the sights and sounds and smells without even going out of my front door. Certainly they kept me awake until long after my bedtime but how worth it. Nevertheless I used to be quite glad to hear the National Anthem played...'

(Stratford n.d [c]).

One of her friends, Alice Curson lived on the opposite side of the Market Place and as they were both girl guides they were able to communicate from their windows by semaphore and Morse code (using short and long strips of white paper to signify dots and dashes). How ingenious, and how different from today's use of mobile phones!

Audrey's interest in buildings shows in her notes as she reflected on the layout and function of the building itself and whether the cupboard in her attic room might have been a powder closet (in which hair or wigs would be powdered in eighteenth century). It appears that, in her usual energetic way, she followed this idea up as there are several documents in the archive about historical wigs.

Her Interest in Buildings: The Bennals
This interest in buildings is also clearly seen in her research into the house, known as the Bennals, in which she and her family lived from 1942, and where she lived for the rest of her life. She clearly intended to write the history of the house, and one set of notes (Stratford n.d. [e]) is headed:

<div align="center">

'THE STORY OF A HOUSE IN KING'S LYNN
told quite unacademically by
ITS PARTIAL AND PREJUDICED OWNER
AMS'

</div>

In the same notes she went on to state:

> 'Thanks to a virtually complete series of deeds and to local memory the story of these interesting buildings and their occupiers is known in some detail from 1905 when the site was laid out as the Chase Garden Estate.'

> (Stratford n.d. [e]).

Using council minutes Audrey was able to research the history of the Chase area before 1905, the activities of the three developers: William Samuel Miles (auctioneer), Frederick Augustus Curzon (solicitor's clerk

or accountant), Sir Alfred Jermyn (draper), the kind of estate being planned, the purchase of the land, permission to build (given in May 1907), and the design of the buildings.

The Bennals is one of a pair of interesting semi-detached Arts and Crafts style houses designed by the local architect Ralph Scott Cockerill. It is possible that these were the only houses he designed in Lynn but he is known to have been active in Great Yarmouth and in Lowestoft (Scott Wilson Ltd 2007). Originally called 'Northbury' and 'Westbury' each half of the pair is rather different (unlike most semi-detached houses) and Audrey speculated on the design of the building and whether it was always intended to be two separate houses (Fig. 8.4). She discovered that 'Northbury' had been renamed 'The Bennals' by previous owners, after a farm in Ayrshire with which they had family connections. She also investigated the ownership of 'Westbury' which had become the Methodist Manse.

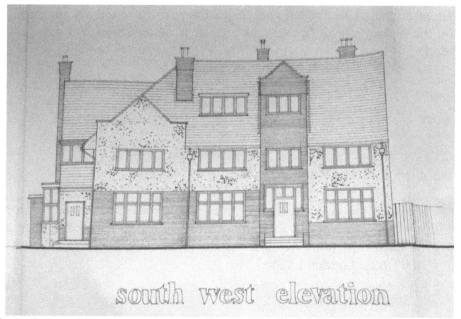

Figure 8.4. Architect's drawing of the south-west elevation of the two houses - The Bennals on the left and the Methodist Manse on the right. Box 43, Document prepared by Malcolm Whittley and Associates (Courtesy of the Trustees of the Audrey Muriel Stratford Charitable Trust).

Her memoir provides detailed description of the internal arrangements of The Bennals, including problems with the water tank in the roof and the awkward bathroom window which could not be opened (she wondered whether this indicated that the bathroom was added later). She also gives details of the servants' quarters (kitchen, scullery and outbuildings, plus two large attic rooms) suggesting that the internal step was the equivalent of the green baize door dividing servants from family. However, there is no indication that there were any servants while she and her family lived there - another indication of social change during the twentieth century.

In the archive there is extensive correspondence concerning The Bennals between Audrey and two different architects, Eric Loasby in the 1960's and Malcolm Whittley and Associates in the 1990's. This together with household bills and other information also in the archive would form the basis of an interesting material and social history of the house.

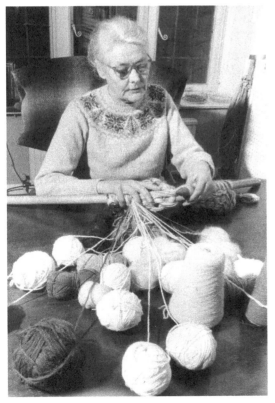

Her Interest in Knitting

Another of her interests which must be mentioned was knitting. She experimented with, and wrote about, knitting with all types of yarn, wool, raffia, foil, plants and ribbons and with needles of all sizes. Figure 8.5 shows her knitting with multiple yarns and modified broom handles!

Again using the name of 'Audrie' Stratford, she wrote two books on knitting

Figure 8.5. Audrey Stratford knitting with multiple yarns and needles made from modified broom handles (Courtesy of the Trustees of the Audrey Muriel Stratford Charitable Trust).

(Stratford 1972 and 1987), and produced a version on tape intended to teach blind people how to knit. Copies are deposited in the archive and the first book - *Introducing Knitting* - can still be bought online. Her aim was to help new and established knitters to achieve good, or better, results.

Her Trust and Archive

Audrey wanted her interest in Lynn and its history to be sustained after her death so she set up the *'Audrey Muriel Stratford Charitable Trust'* and bequeathed her personal papers to form an archive. The key objective of the Trust is to:

> 'To benefit the inhabitants of King's Lynn and to advance education by the establishment and maintenance of a collection of documents, records and recordings illustrating as completely as reasonably practicable the past, contemporary and developing history of King's Lynn'.

(AMSCT 2017).

Her archive (*The Audrey Muriel Stratford Papers*) which belongs to the Trust is housed in the King's Lynn Borough Archives. It is a large collection (196 boxes in all) catalogued and sorted into broad subject areas (Jayasooriya 2003). There are also over a thousand books stored elsewhere. Types of papers represented include correspondence, diaries, school reports and exercise books, college notes, ration books, photographs, newspaper cuttings, and typed copies of deeds and other legal documents relating to properties in King's Lynn and the local area. Apart from papers it also includes a number of framed pictures, and miscellaneous objects.

Particularly interesting are Audrey's own notes covering her research and reminiscences, typed on her Amstrad computer and printed out on continuous perforated paper (itself now a thing of the past). In a letter to the Society of Authors dated 5th March 1990 (when she was already 82), she stated:

> 'I am busy pouring data into my word processor and want so to arrange things that there is a good chance that the material will be

used beneficially [...] At present I am still more than busy accumulating and labelling illustrative material or typing out each subject or anecdote as it occurs to me, unselected, uncorrected, unco-ordinated, but at least in some form recorded. [...] When the time comes I want all my discs printed out and the results combined with the growing accumulation of labelled photographs, cuttings, summaries of the transcripts of the deeds of our properties (which often include enchanting details)...'

(Stratford 1990).

The archive offers a rich source of information on her personal history including her education, interests and activities, on the history of her immediate and extended family, on the history of the family firm, and on a wide range of local and national issues. She showed considerable foresight in preserving papers and other ephemera:

'What many people find difficult to grasp is that the [old] photos they are finding so interesting were merely casual dull prints to someone a couple of generations ago and the present photos, disregarded on the assumption that 'everyone knows about that' will be of just as great interest in a couple of generations'.

(Stratford n.d. [f]).

Of course she was right! As time passes her archive will become increasingly interesting and valuable.

Conclusions
Audrey Stratford was an interesting woman who made a considerable contribution to changes and developments in King's Lynn during her life-time. She was able to put her personal and financial independence to good use in supporting important causes such as the welfare of women, and improvements to local housing, and at the same time she pursued her own interests in local and family history. Her Trust provides a lasting legacy for King's Lynn, and her archive is a rich source of information about life in the twentieth century. She certainly deserves to be remembered, and her archive deserves to be explored more fully.

Acknowledgements

The Trustees of the Audrey Muriel Stratford Charitable Trust for permission to use material belonging to the Trust; the King's Lynn Borough Archives; members of Soroptimist International King's Lynn; Dr. Elizabeth Harrison and Dr. Paul Richards for their memories of Audrey Stratford.

Appendix

Organisations mentioned in this chapter:

Local Organisations:

The Audrey Muriel Stratford Charitable Trust Registered Charity No: 1045027
www: http://amstratford-trust.org

King's Lynn Borough Archives, King's Lynn Town Hall, Saturday Market Place, King's Lynn PE30 5DQ
(These archives house the Audrey Muriel Stratford Papers)
www: http://www.archives.norfolk.gov.uk/Archive-Collections/Kings-Lynn-Borough-Archives/index.htm

Stratfords Ltd
www: http://www.stratfords.com/pages/About-Us.html

Women's Groups:

The British Federation of Women Graduates
Founded in 1907; the voice of women graduates in England and Wales, aims to promote the importance of education for women and girls.
www: https://bfwg.org.uk

National Council of Women
Founded in 1895; aims to secure the removal of discrimination against women and to encourage the effective participation of women in the life of the nation.
www: http://ncwgb.org

Soroptimist International of GB & Ireland Ltd
Soroptimist International is part of a global organisation, founded 1921, which is committed to a world where women and girls achieve their individual and collective potential. Soroptimist International has consultative status at the Economic and Social Council (ECOSOC) at the United Nations. Audrey Stratford was a member of the King's Lynn Branch, founded in 1975.
www: https://sigbi.org/kings-lynn

Note all three bodies are members of the *6.0 Group of Women's Organisations*, which brings together the six leading women's groups in the UK. The other members are the National Federation of Women's Institutes, the Townswomen's Guild, and Business and Professional Women UK.
www: https://www.thewi.org.uk/
www: http://the-tg.com/
www: http://www.bpwuk.org.uk/

Documents in '*The Audrey Muriel Stratford Papers*' Archive
Stratford, A. n.d. [a]. 'Vehicles'. Box 189, C/P/602.

Stratford, A. n.d. [b]. 'An outline life history of a most fortunate person'. Box 155, U/B /54-56.

Stratford, A. n.d. [c]. 'My enjoyment of Tuesday Market surroundings'. Box 189, C/P/601.

Stratford, A. n.d. [e]. 'The Story of a House in King's Lynn'. Box 190, History A 947.

Stratford, A. n.d. [f]. 'Suggestions for Trust Activities'. Box 155, U/B /54-56.

Stratford, A. 1990. 'Letter to the Society of Authors, 5th March 1990'. Box 155, U/B/49.

Stratford, A. 1993. 'Suggested Guidelines [for the Trust] intended to be 'flexible', December 1993'. Box 155, U/B /54-56.

References

AMSCT 2017:
The Audrey Muriel Stratford Charitable Trust, 2017. *'About the Trust – Objects of the Charity'*. Available at: http://amstratford-trust.org/objects-of-the-charity/ [Accessed on 29/10/17].

Fuller, R., 2011. *Audrey's Journey: One Lady's Lifetime in Lynn* [Film]. An Audrey Muriel Stratford Charitable Trust Presentation. King's Lynn: Robert Fuller Associates.

Jayasooriya, G., 2003. *Report on the Papers of Audrey Muriel Stratford 1907 – 2000 of King's Lynn.* Prepared for the Trustees of the Audrey Muriel Stratford Charitable Trust. King's Lynn: The Norfolk Record Service.

Last, M., 2007. 'Extraordinary Audrey'. *Lynn News,* Tuesday, 28th August 2007. Available at:
www: http://www.lynnnews.co.uk/news/extraordinary-audrey-1-514403
[Accessed on 29/10./17].

Scott Wilson Ltd, 2007:
Scott Wilson Ltd and the Waveney District Council Conservation Team 2007. *North Lowestoft conservation area character appraisal.* Lowestoft: Waveney District Council.

Stratford, A., 1972. *Introducing Knitting.* London: Batsford.

Stratford, A., 1987. *Nowadays Knitting for New Knitters.* Wisbech, Cambs: Castle Press.

Stratford, A., 1988. *The Committee Book.* Slough, Bucks: W. Foulsham & Co.

Chapter Nine

Miss Diana Bullock
and
Lady Joan Evershed

Jill Price

Abstract
This chapter is a brief overview of two remarkable and influential women involved in the conservation of, and the promotion of Heritage in King's Lynn and West Norfolk.

Introduction
In the middle of the twentieth century two remarkable, socially connected and learned women contributed to the success of conservation and promotion of historic buildings in King's Lynn and West Norfolk: Miss Diana Bullock and Lady Joan Evershed.

Miss Diana Bullock: a personal reminiscence
My links with Diana came about because of her initiating what became King's Lynn Town Guides in 1977 (Fig. 9.1). My husband and I moved here from Kent in 1973, and in our first year here had sixty three people to stay! We read up as much as we could about Lynn, and took them on Sunday morning walks so when a notice appeared in the *Lynn News* about a course for people interested in the history of the town, we went along. Diana was the driving force, and eventually eleven of us qualified as Blue Badge Guides. That was forty years ago, and the Town Guides continue to go from strength to strength. Eighty two people have become Guides. There are nearly thirty at the moment and we are all volunteers. We have guided thousands of people and given thousands of pounds to conservation and preservation projects in the town. This is, all due to one woman's drive and dedication. And this is only one aspect of Diana's legacy to Lynn.

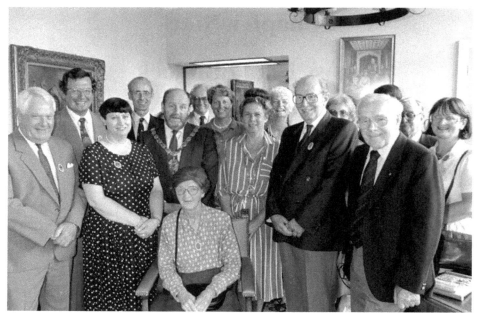

Figure 9.1. Diana Bullock seated, surrounded by a group of King's Lynn Town Guides in 1993 (© Bob Price 1993).

Biographical Note

Miss Diana Bullock, B.Sc. (Econ), took up her post at Gaywood Park Girls' School in January 1952 and she was Headmistress for the next twenty years. After taking a degree in Economics at Nottingham University she taught in London before coming to Norfolk during WWII to join the staff of Thetford Girls' Grammar School. Then in 1945 she moved to Lynn to take charge of the Special Experimental Grammar School.

Even before she retired in July 1972, Diana Bullock had been very involved in the local community. She had joined the King's Lynn Civic Society in 1951 and had served on the executive committee since 1952. For two years from 1977 to 1979 she was Chairman and then for thirteen years was the Society's President. When she resigned in 1992 the committee marked her service by commissioning a special bench suitable for use by disabled people which was originally erected in New Conduit Street with a view of the Customs House but is now in Saturday Market Place. Miss Bullock was also a founder member of the King's Lynn Preservation Trust and helped to set up the Town Guides. She was

awarded an OBE in the 1967 New Years' Honours list for services to education and the local community. Diana Bullock died in 1994 aged 86.

Lady Joan Evershed

In 1953 Mrs. E. A. Lane bought Hampton Court (Fig. 9.2), saving it from demolition, and restored the East and West wings (restored 1955-60; KLPT 2017). She then looked for someone responsible to finish the job. Eventually it was offered to the Civic Society, who accepted it, but who realised it was not within their rules to take on such a task. Luckily, Lady Joan Evershed was the Chairman at the time. Lady Joan Evershed was Cecily Elizabeth Joan Bennett, daughter of Sir Charles Alan Bennett (Pine 1972, 118). After her marriage in 1928 she was known as Lady Evershed.

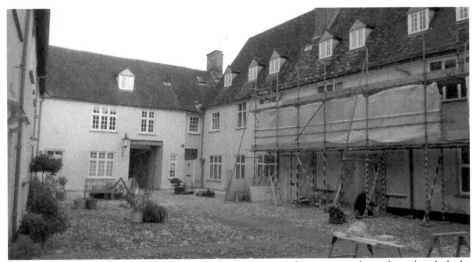

Figure 9.2. Hampton Court, looking south-east across the courtyard, as the wing is being re-rendered, building conservation in action, 30th October 2017 (© Clive Bond 2017).

Not only was Lady Evershed Chairman of the King's Lynn Civic Society, but most usefully, a member of the Society for the Protection of Ancient Buildings (SPAB). After consultation, the King's Lynn Preservation Trust was formed in 1958, and under her guidance as Chairman, went from strength to strength, saving and re-using so many buildings. Her husband, Lord Evershed was Master of the Rollls, and they lived in Setch Hall. There is a memorial to her, in Hopton stone, in the courtyard of Thoresby College.

Acknowledgements

I would like to thank Michael Walker, for his help with the biographical note on Diana Bullock, drawn from his research (Walker forthcoming). I wouldd also like to thank Michael Walker and Bob Price, Chairman of the King's Lynn Town Guides, for providing the picture of Miss Diana Bullock.

References

KLPT:

King's Lynn Preservation Trust 2017. *Past Projects – Hampton Court.* Available at: http://www.klprestrust.org.uk/archive/hampton-court/ [Accessed at 29/10/17].

Pine, L. G. 1972. *The New Extinct Peerage 1884-1971: Containing Extinct, Abeyant, Dormant and Suspended Peerages with Genealogies and Arms. Heraldry Today*, 118. Available at: *http://www.thepeerage.com/p23394.htm#i233935* [Accessed 29/10/17].

Walker, M. Forthcoming. *The Gaywood Park Schools, 1939-1979.*

Chapter Ten

The World War I Zeppelin Shrapnel Cross Artefact, Lynn Museum

Alexandra Lee

Abstract

This chapter reports on a museum visit to describe a unique artefact, a metal cross, shaped out of shrapnel from a zeppelin bomb, dropped on King's Lynn on the evening of the 19th January 1915. The airship raid killed two citizens; it was part of the first raid by any one Zeppelin on UK territory. A portent of 'Total War' *(Marwick 1970), on the people of West Norfolk!*

Introduction

For those unfamiliar with the First World War Zeppelin raids on Britain, it may be surprising to discover that the very first airship attack took place not over London or some other major British city, but over East Anglia. During the whole period of the war, Germany made extensive use of Zeppelins as bombers and scouts, eventually killing over five hundred people during bombing raids on Britain.

In January 2015, to mark this particularly important time of *Remembrance*, Lynn Museum had a special exhibition dedicated to the First World War. Among the artefacts, was a display relating to that first local airship 'Graf Zeppelin' raid in 1915.

Zeppelin Shrapnel Cross

'Above is a piece of the bomb dropped from the Zeppelin. It killed the little boy Goat in Bentinck Street, Lynn. E. M. Beloe, Coroner'.

This handwritten inscription appears on a public notice about damage claims, which has been pasted onto a wooden plaque in one of the

Museum's display cases (see Appendix and Fig. 10.1 and 10.2). The plaque is fashioned from a piece of wooden board, approximately 13cm wide by 20cm long, and it has 4 screw holes in the corners suggesting that it was once mounted. Above the pasted notice is a small drilled circle. Suspended from a piece of twisted wire inside hangs a small piece of Zeppelin shrapnel shaped into the style of an 'Iron Cross'. A symbol of the German Army from 1871 to 1918, this potent design was later re-introduced as an award in the German Army, with a Swastika added in the centre, during WWII.

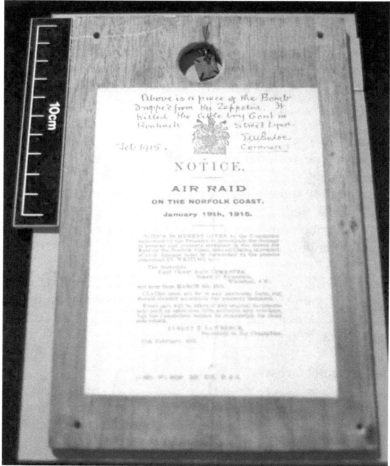

Figure 10.1. Notice, pasted on to wooden plaque, with E. M. Beloe's hand written inscription and above, centre circle void, drilled with shrapnel cross hung. Ten centimetre scale, left side (© Alexandra Lee 2014).

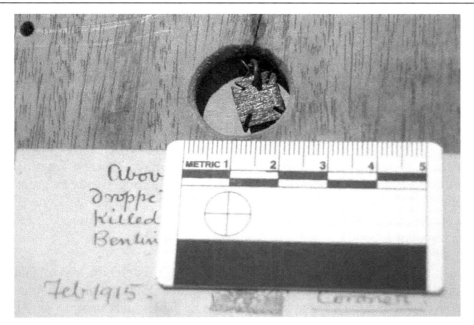

Figure 10.2. A close-up, detail of the circular void, drilled in the wooden plaque, with shrapnel cross hung of a pin with an eye. Five centimetre scale (© Alexandra Lee 2014).

The plaque is listed as an 'untraced find', and we know little about its origin, other than that it was transferred to Lynn Museum from the Greenland Fishery Museum when that building was bombed in WWII. We can only guess at how this keepsake came to be made, or archived. In a letter to the Home Office, dated 5th February 1915, local Chief Constable, Charles Hunt, writes,

> '...some fragments of the bombs were found after the raid, and continue to be found. One was handed over to the Naval Authorities, the other pieces, which I now have in my possession, will be despatched to the same Authorities tomorrow'.

> (Hunt 1915).

It may be likely that, as this little cross is so small, it was found and shaped by a local citizen, then somehow making its way into the hands of the Coroner.

L4 Zeppelin Raid on King's Lynn, 19th January 1915

Zeppelin airship raids on Britain were first authorised by the Kaiser on 7th January 1915, although he excluded London as a target and demanded that no attacks be made on historic buildings. The first raids were intended to target only military sites on the east coast and around the Thames estuary, but bombing accuracy was poor, owing to the height the airships flew, and navigation was also problematic (Stephenson 2004).

On the 19th January, 1915, two Zeppelins, L3 and L4, set off with the intention to attack Humberside, but diverted by strong winds eventually dropped their bombs on Great Yarmouth, Sheringham, Kings Lynn and the surrounding villages. That night, they killed four and injured sixteen, causing over £7,000 of damage (Anon 1915; Clover n.d., 27-33).

At 10:00 pm that evening, Chief Constable Hunt received a report that a Zeppelin L4 had been seen over Yarmouth and Sheringham and that it had dropped bombs in that area. Before he had much time to act, the Zeppelin had arrived over King's Lynn. It dropped bombs in a field by the railway line, allotments by the railway station - within a few yards of the Royal Coaches, onto Bentinck Street, East Street and Albert Street, Creswell Street, an allotment near Sir Lewis Street, and into a garden near the Docks. Finally, it caused considerable bomb damage to the engine room and surrounding buildings at the Power Station of the King's Lynn Docks and Railway Company.

Sadly, it was the bomb at Bentinck Street that caused loss of life in King's Lynn. This was a well-populated area, and two houses were demolished by the bomb, with others badly damaged. One young man, Percy Goat, 14, was killed in a house, and Alice Maud Gazely, 26, was killed by the falling of another. Alice had recently lost her husband of 5 years, Private Percy George Gazely, killed in action in October 1914. She was staying with friends when the bombs fell. As she heard the bombs falling, she ran, panicked, out into the street and her body was found the next day in the rubble.

Remarkably few people were injured and many had miraculous escapes in this densely-populated area of Lynn. Percy Goat's mother painted a vivid

picture of events in her statement to the Inquest Jury on the 21st January 1915:

'My husband put out the lamp and I saw a bomb drop through the skylight and strike the pillow where Percy was lying. I tried to wake him, but he was dead'.

(Inquest Jury 1915).

Both death certificates cite the cause of death as being, 'from the effects of the King's Enemies'.

Percy and Alice are buried at the Hardwick Cemetery in Kings Lynn. Their tragic deaths were remembered there, with a small gathering and service on the hundredth anniversary of the first raid in January 2015.

By the end of World War I over sixty Zeppelins had been lost, with half to enemy action and half to accidents. They had made over fifty raids and dropped almost six thousand bombs. Life for the families in Bentinck Street would never be the same again.

Acknowledgements
I would like to thank the staff and, Dayna Woolbright, the Assistant Curator, at Lynn Museum (Norfolk Museums Service), for being so helpful during my visit in November 2014. A version of this article was researched for, and part of, the West Norfolk and King's Lynn Archaeological Society's project Norfolk Community Foundation funded, *Zeppelins over Lynn and the Royal Flying Corps Home Defence'*. Further information on that project is accessible at: www.greyhawk.org.uk/ww1/main.php

Appendix
The entry for the Zeppelin Shrapnel Cross at Lynn Museum, Norfolk Museums Service, King's Lynn is accessioned as the following:

Notice

Description: Notice regarding bomb damage claims; for damage during raid on the Norfolk Coast January 19th 1915; pasted on board; a piece of metal hangs in a circle at

the top 'Above is a piece of the bomb dropped from the Zeppelin. It killed little boy Goat in Bentinck Street, Lynn. E. M. Beloe, Coroner.'

Material: Paper.

Measurements: 130 (unknown) 205 (unknown)(mm).

Accession number: KLLM: 1977.114.

On display at: Not currently on public display.

References

Anon 1915. 'How Germany's "Scare-Ships" failed to scare in Coast'. *The Daily Mirror*, January 21, 1915, 1-2.

Clover, C. n.d. *Zeppelins over the Eastern Counties.* Part of the Once Upon a Wartime series No. 17. Edited by Molly Burkett. Grantham: Barny Books.

Hunt, C., 1915. *Letter to the Home Office, dated 5th February 1915, from, Chief Constables Office, Town, King's Lynn.* Copy in possession of Lynn Museum and King's Lynn Library, King's Lynn (Index No. AIRI/552 907; 283.152/3). King's Lynn: Norfolk Library Service.

Inquest Jury 1915. *Public Inquest Jury Papers.* Copy in possession of Lynn Museum, King's Lynn: Norfolk Museums Service.

Marwick, A. 1970. *Britain in the Century of Total War: War, Peace and Social Change 1900-1967.* Harmondsworth: Pelican.

Norfolk Collections 2017. *Norfolk Museums' Collections - Catalogue: Accession Number: KILLM: 1977.114.* Available at: www.norfolkmuseumscollections.org/collections/objects/object-3087201389.html/#!/?q=zeppelin%2BLynn [Accessed on 30/10/17].

Stephenson, C. 2004. *Zeppelins: German Airships 1900-40.* New Vanguard 101. Oxford: Sprey Publishing.

Chapter Eleven

The St Margaret's Townscape Heritage Initiative

Elizabeth Nockolds

Abstract

This chapter briefly reviews the progress of the Borough Council of King's Lynn & West Norfolk's successful Heritage Lottery Fund Bid 'St Margaret's Townscape Heritage Initiative (THI).

Introduction

The St Margaret's Townscape Heritage Initiative (or THI) is a jointly funded project, £1m from the Borough Council of King's Lynn & West Norfolk (BCKL&WN) and £1m from the Heritage Lottery Fund (HLF, see BCKL&WN 2017). Therefore, a total fund of £2m is involved in delivering this heritage-led regeneration project. St Margaret's THI aims to tackle some of the buildings which blighted the town centre, bringing them back into use, addressing outstanding long-standing historic building repairs. The methodology used is also aimed at helping to make historic buildings viable, as commercial and/or residential properties, able to contribute to regeneration, for future uses as homes and businesses. This work is aimed at making a positive contribution to the conservation area; generating new uses, for historic, and some listed buildings. The THI covers much of the Borough Council of King's Lynn & West Norfolk's St Margaret's Conservation Area (BCK&LWN 2008, 2013a and b)(Fig. 11.1).

Early Results

By investing £1m BCKL&WN have tackled the three critical projects outlined in our design and successful bid (Fig. 11.2):

- Greyfriars Chambers,
- 9/11 St James Street

- Wenns Hotel.

A further eight historic properties have all successfully applied for grant aid, with some projects complete, others under construction and some to start later in the 2017/2018 period.

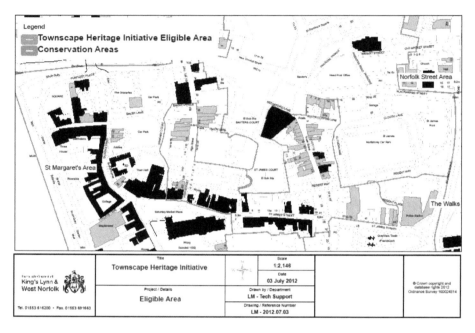

Figure 11.1. St Margaret's Conservation Area and its relationship to the Townscape Heritage Initiative area (eligible for grants) (Produced courtesy of the Borough Council of King's Lynn and West Norfolk).

To date with two years still remaining this investment has led to a leverage of some £1.46m of private sector investment, over some 11 properties receiving grant aid. At 9/11 St James Street alone, some £800,000 is being invested back into the private sector, in developing a complex of seven residential units and transforming one of the key blighted buildings of the town centre. Affordable residential property is critically in need in the town centre. Importantly, bringing empty properties into use also provides revenue back to BCKL&WN: the seven residential properties at 9/11 St James Street are set to generate between c.£1,200 and c.£1,400 each of Council Tax. Indeed, project

colleagues also estimate the newly refurbished Wenns Hotel will generate between c.£25,000 and c.£30,000 in Business Tax.

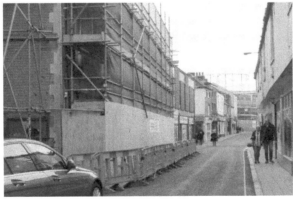

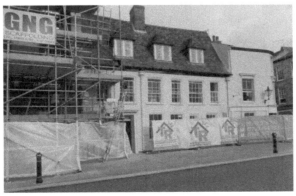

Figure 11.2. Top: Greyfriars Chambers; Middle: 9/11 St James Street; Bottom: Wenns Hotel. Conservation works in progress, 24th October 2017 (© Elizabeth Nockolds 2017).

Overall some c.£140,000 was invested into the public realm, focusing on the re-ordering and repaving of the Saturday Market Place. These works have also included a well designed outline of the uncovered floor plan of the medieval charnel chapel.

Community Events

Further to capital works on buildings, the THI has included outreach community-centre initiatives to raise the importance of this built historic environment, with local and new audiences. A programme of complimentary activities has raised the profile of the town's heritage and the THI area, through training, educational and community events. A key highlight of these events has been the 'Beer, Butchers and Barbers' public event (Fig. 11.3).

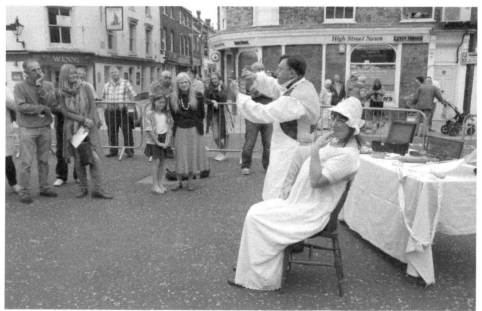

Figure 11.3. 'Beer, Butchers and Barbers' fair on the Saturday Market Place, September 2015 (© Elizabeth Nockolds 2015).

This popular outreach event was held in the Saturday Market Place, historically the location of town fairs/markets (BCKL&WN 2014). This was also the location of the historic, *The Shambles* (which included butchers) and other local sellers.

Acknowledgements

I'd like to thank my colleagues at the Borough Council of King's Lynn, for their help in producing this chapter: Ostap Paparega, Regeneration & Economic Development Manager, Stephen King, THI Project Officer and Cllr. Alistair Beales, Cabinet Member for Corporate Projects and Assets.

References

BCKL&WN 2008:
Borough Council of King's Lynn & West Norfolk 2008. *St Margaret's Area Conservation Area Character Statement.* Approved July 2003. Revised November 2008. King's Lynn: Conservation Team, Borough Council of King's Lynn & West Norfolk.

BCKL&WN 2013a:
Borough Council of King's Lynn & West Norfolk 2013a. *St Margaret's Conservation Area Character Appraisal.* December 2013. Midhurst: The Conservation Studios.

BCKL&WN 2013b:
Borough Council of King's Lynn & West Norfolk 2013b. *St Margaret's Conservation Area Management Plan.* December 2013. Midhurst: The Conservation Studios.

BCKL&WN 2014:
Borough Council of King's Lynn & West Norfolk 2014. *St Margaret's Townscape Heritage Initiative 2014-19. Townscape Heritage News.* Issue One, summer 2014. King's Lynn: Regeneration, Borough Council of King's Lynn & West Norfolk.

BCKL&WN 2017:
Borough Council of King's Lynn & West Norfolk 2017. *Townscape Heritage Initiative.* Information about the lottery funding for St Margaret's Conservation Area. Available at:
www.west-norfolk.gov.uk/info/20081/conservation_and_listed_buildings/141/tow nscape_heritage_initiative [Accessed on 23/10/17].

INDEX

Lightning Source UK Ltd.
Milton Keynes UK
UKHW02f2236171117
312848UK00004B/36/P